LAND & LIGHT WORKSHOP

Painting Mood & Atmosphere in Oils

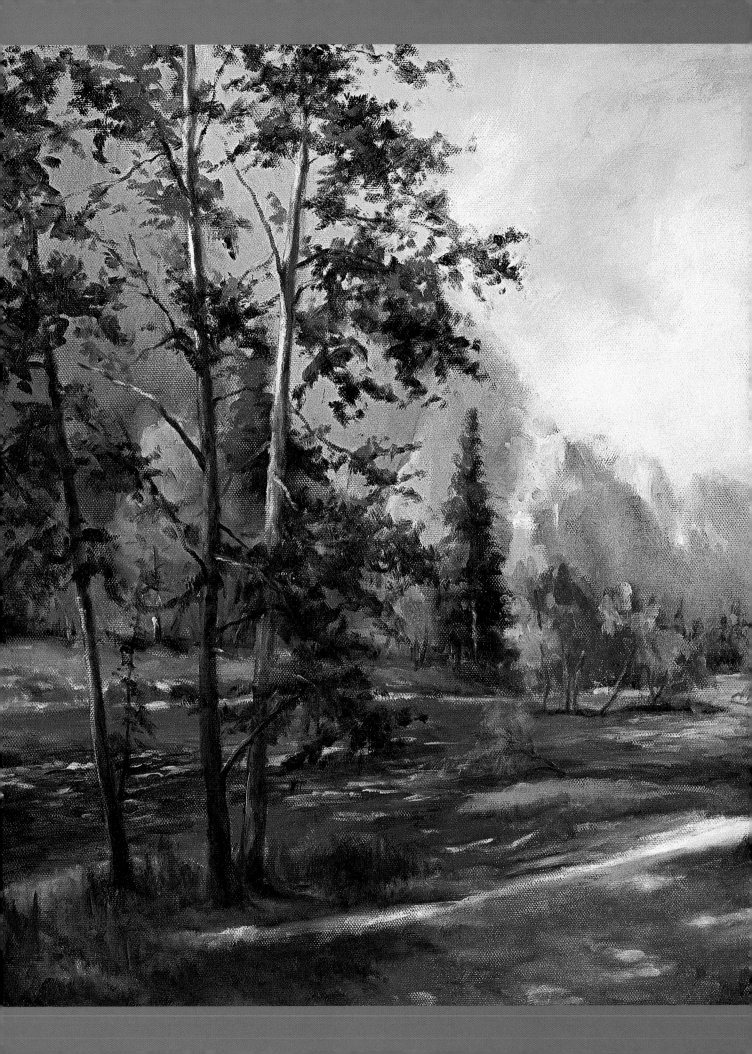

PAINTING
Mood & Atmosphere
IN OILS

Carolyn Lewis

NORTH LIGHT BOOKS
CINCINNATI, OHIO
www.artistsnetwork.com

Photo by Dennis Roliff

Land & Light Workshop: Painting Mood & Atmosphere in Oils. Copyright © 2005 by Carolyn Lewis. Manufactured in China. All rights reserved. No part of this book may be reproduced in any form or by any electronic or mechanical means including information storage and retrieval systems without permission in writing from the publisher, except by a reviewer who may quote brief passages in a review. Published by North Light Books, an imprint of F+W Publications, Inc., 4700 East Galbraith Road, Cincinnati, Ohio, 45236. (800) 289-0963. First Edition.

Other fine North Light Books are available from your local bookstore, art supply store or direct from the publisher.

09 08 07 06 05 5 4 3 2 1

DISTRIBUTED IN CANADA BY FRASER DIRECT
100 Armstrong Avenue
Georgetown, ON, Canada L7G 5S4
Tel: (905) 877-4411

DISTRIBUTED IN THE U.K. AND EUROPE BY DAVID & CHARLES
Brunel House, Newton Abbot, Devon, TQ12 4PU, England
Tel: (+44) 1626 323200, Fax: (+44) 1626 323319
Email: mail@davidandcharles.co.uk

DISTRIBUTED IN AUSTRALIA BY CAPRICORN LINK
P.O. Box 704, S. Windsor NSW, 2756 Australia
Tel: (02) 4577-3555

Library of Congress Cataloging in Publication Data
Lewis, Carolyn
 Land & light workshop : painting mood & atmosphere in oils / Carolyn Lewis.
-- 1st ed.
 p. cm.
 Includes index.
 ISBN 1-58180-631-0 (hardcover : alk. paper)
 1. Landscape painting--Technique. I. Title: Land & light workshop. II. Title.
 ND1342.L48 2005
 751.45'436--dc22 2005002177

Edited by Stefanie Laufersweiler and Amy Jeynes
Designed by Wendy Dunning
Production art by Donna Cozatchy
Production coordinated by Mark Griffin

ABOUT THE AUTHOR

Nature, wildlife and people inspire artist Carolyn Lewis to create work that is sensitive without being overly sentimental. Her powerful landscapes and commissioned portraits of people and animals are steadily gaining acclaim in national art circles.

Carolyn went after her dream by taking classes in drawing, then in painting. She received her fundamental training from Jack Richard. Other influential teachers of hers were Marc Moon, Dino Massaroni and Chuck Marshall.

Carolyn has had several solo exhibitions and has been selected to exhibit in numerous local, regional and national art competitions. Among her many awards is an Honorable Mention from *The Artist's Magazine*'s 1998 National Landscape Competition. She was published in *Artist's Photo Reference: Landscapes* (North Light Books, 2001). She was one of the top two hundred finalists in the prestigious Art for the Parks exhibition, and she has received a Best in Show from the Cuyahoga Valley Art Center annual Members Show. She was a finalist in the Winsor & Newton 1994 National Calendar Competition as well as in the Artist's Magazine 1991 National Portrait Competition.

Carolyn is a signature member of the Akron Society of Artists (which has played an important role in her career since 1982), the Cuyahoga Valley Art Center, Oil Painters of America, the Portrait Society of America, the Ohio Plein Air Society, the Cincinnati Art Club and the Portrait Painters Guild. She is a member of the American Impressionist Society.

Carolyn has been an instructor at the Cuyahoga Valley Art Center in Cuyahoga Falls, Ohio, since 1994 and has been represented by The Lawrence Churski Gallery in Bath, Ohio, since 1996. She teaches private lessons and workshops and judges competitions. Carolyn has lived in northeastern Ohio all her life. She and her husband, Jim, have two wonderful daughters.

METRIC CONVERSION CHART

TO CONVERT	TO	MULTIPLY BY
Inches	Centimeters	2.54
Centimeters	Inches	0.4
Feet	Centimeters	30.5
Centimeters	Feet	0.03
Yards	Meters	0.9
Meters	Yards	1.1
Sq. Inches	Sq. Centimeters	6.45
Sq. Centimeters	Sq. Inches	0.16
Sq. Feet	Sq. Meters	0.09
Sq. Meters	Sq. Feet	10.8
Sq. Yards	Sq. Meters	0.8
Sq. Meters	Sq. Yards	1.2
Pounds	Kilograms	0.45
Kilograms	Pounds	2.2
Ounces	Grams	28.4
Grams	Ounces	0.035

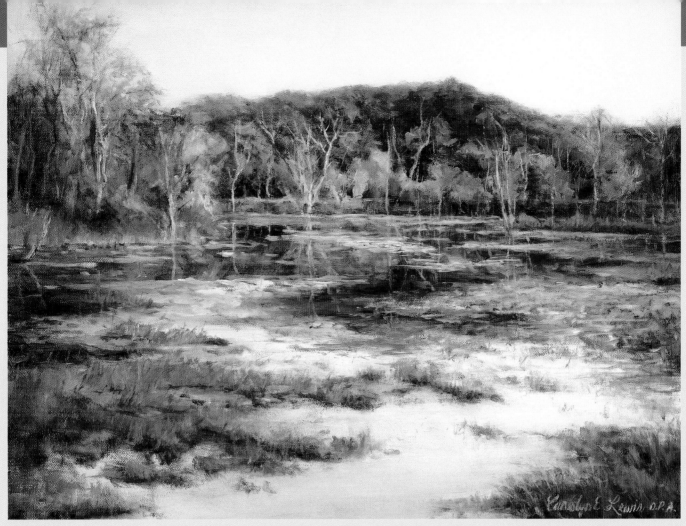

Autumn Marsh • *Oil on canvas* • *16" × 20" (41cm × 51cm)*

ACKNOWLEDGMENTS Thanks to all of the following: Dennis Roliff of Dennis Roliff Photography for his excellent work in photographing most of the art work for this book. His professionalism and patience were there always.

Barbara Krans Jenkins and Gary Greene for making possible my publication in *Artist's Photo Reference: Landscapes*.

My son-in-law Giuliano Hofling for reference photos used for pages 30 and 120; and a very special friend, Ron Schaefer, for reference photos used for pages 32, 81 (*Autumn Blaze*) and 108. Both of these men are wonderful photographers.

My editors, Stefanie Laufersweiler and Amy Jeynes, who have given me the guidance and support needed for doing this monumental task.

My husband Jim, who has been so patient and supportive as I worked on this book.

All my instructors for passing on their knowledge over the years.

My artist friends who have given me so much encouragement. Thank you so much.

I would also like to thank God for blessing me with this special gift.

DEDICATION *To my loving husband Jim, who has always been there for me, and to the rest of my family for all their support and encouragement.*

TABLE OF CONTENTS

An introduction to paints, palettes, brushes, surfaces, mediums and other supplies you'll need to enjoy oil painting in the studio and outdoors.

CHAPTER I

PAINTING TECHNIQUES *and the* BASICS OF MIXING COLOR *14*

Before you set out to do your own thing, it pays to learn the basics. This chapter will explain the oil painting process and teach a variety of brush techniques. Learn how to mix colors, to choose colors to communicate a mood, and to use value and color temperature to strengthen your paintings.

CHAPTER 2

PLAN A STRONG COMPOSITION *30*

Once you decide what you want to paint, the first challenge is to compose your painting in a way that draws the viewers' attention to the subject. Learn how to choose shapes, colors, values and format to best communicate the mood you have chosen.

CHAPTER 3

CAPTURE LIGHT *and* SHADOW *46*

Examples and three step-by-step demonstrations show you how light varies in color and mood at different times of day and how you can create light and shadow in your paintings.

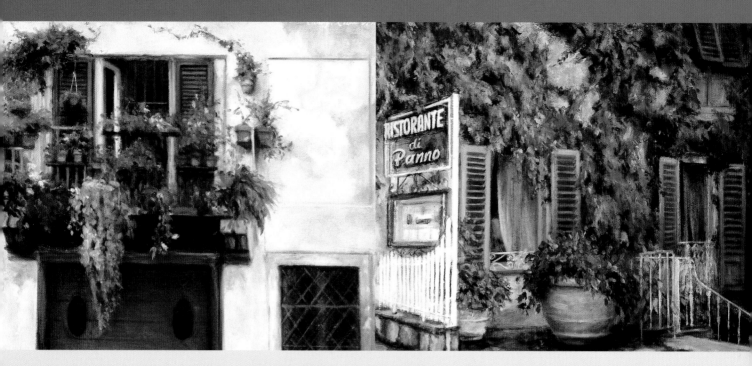

CHAPTER 4
CHANGE WITH THE
WEATHER *72*

Painting outside in the elements can make your paintings more convincing because you, the artist, feel the weather conditions you want your viewers to feel. Learn how to capture fog, overcast days, reflections in rain, and the feel of the seasons by painting along with the three mini demonstrations and three step-by-step demonstrations in this chapter.

CHAPTER 5
FROM PLEIN AIR
to the STUDIO *100*

Painting from life is an essential experience that will make you a better studio painter, but it's equally important to be able to paint from photos and from memory. Three step-by-step demonstrations show you how.

INTRODUCTION

Oil is a wonderful medium with which to start learning how to paint. It is a forgiving medium, and it can produce a wide range of light and color effects. Brushstrokes can vary from delicate to heavily textured. Any subject can be approached with oils, and the richness of oil colors is unsurpassable.

This book focuses primarily on the principles and techniques of painting landscapes in oils. By working through the exercises and the step-by-step demonstrations, you will gain a better understanding of the medium.

I hope this book will help you observe nature in a new way. Once you start drawing and painting, you'll see things differently because you'll pay more attention to your surroundings. You may find yourself constantly making mental notes about colors, values, edges and light to use in paintings.

The more I paint, the more I appreciate that painting from life, whether for a portrait or a landscape, is essential for anyone who wants to become a better artist. It teaches one to make decisions quickly and accurately, skills that help artists in all their paintings.

Even as a child, I knew I wanted to be an artist. Some of my elementary school teachers encouraged me. I hope this book, which has evolved from a lifetime of experiences, gives encouragement and guidance to artists of all ages. My goal is to help any artist become a better painter.

Whatever your goal as an artist, go after it with passion and persistence. Through trial and error, your confidence will build, and your paintings will reflect that confidence. Enjoy the wonderful, fulfilling adventure and the enormous rewards of oil painting!

Carolyn E. Lewis

Flowers in the Piazza · *Oil on canvas* · *20" x 30" (51cm x 76cm)*

Materials for Getting Started

Paints

Buy the best paints you can afford. Quality paints pay off in the end and are generally easier to use. "Student-grade" paints do contain more fillers which makes them less expensive than high-quality paints. The differences are noticeable in some of the colors when mixed but generally, student-grade earth tones are fine.

Palettes

I recommend a medium-gray palette rather than a white one. A gray palette lets you judge color values accurately. A white palette makes colors appear dark; a very dark palette makes colors appear light. (This is also why I paint on a toned canvas, as described on page 16.)

Make sure your palette has ample room for mixing colors. A 12" × 16" (30cm × 41cm) palette is a good size. I stand while I paint, so I find handheld palettes convenient.

One of the palettes I use is a gray, handheld palette called the Dino Massaroni Neutral Palette. This palette can also be stored in a Masterson Palette Seal Box, which is great for transporting a palette with wet paint. This airtight storage container has a snap-on lid and holds up to a 12" × 16" (30cm × 41cm) palette.

To use the Palette Seal Box as a palette, put medium-gray mat board or paper in the bottom of the Palette Seal, then top that with a 12" × 16" (30cm × 41cm) piece of nonglare glass. (Nonglare glass prevents glare from studio lights or sunlight.) Put paints directly onto the glass. For easy cleaning, scrape the glass with a razor blade.

Brushes

Brushes come in many shapes and sizes. I recommend two kinds:

- **Bristle brushes, which are made with hog hair.** These are good for laying in initial shapes. Bristles are very durable and can handle the harsh scumbling used for the first layer. The tapered shape of a filbert works for drawing, and its wider, flatter side works for applying paint over a large area. If your subject calls for sharp edges as those in architecture or rocks, a flat bristle may work better than a filbert.
- **Softer brushes made of sable or mongoose hair.** These are useful for applying a second coat of paint over a wet first coat, because they won't lift up the bottom layer. Again, depending on edges, use either a filbert or a flat. For the finer, thinner details such as branches, figures or a signature, use a round brush with a very tapered point.

Palette Knives

You can use palette knives for mixing, scraping and even applying paint. A trowel shape with an offset handle keeps your knuckles from getting into the paint.

Surfaces

Canvas boards come in a variety of surfaces from acrylic to oil primed and from rough to slick. Some companies offer a

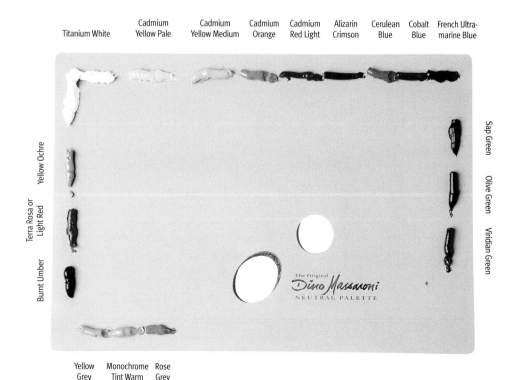

Titanium White | Cadmium Yellow Pale | Cadmium Yellow Medium | Cadmium Orange | Cadmium Red Light | Alizarin Crimson | Cerulean Blue | Cobalt Blue | French Ultramarine Blue

Yellow Ochre — Terra Rosa or Light Red — Burnt Umber

Sap Green — Olive Green — Viridian Green

The Original *Dino Massaroni* NEUTRAL PALETTE

Yellow Grey | Monochrome Tint Warm | Rose Grey

My Palette and Colors

I include on my palette a warm and a cool of each primary color. Examples of cool primaries are Cadmium Yellow Pale, Alizarin Crimson and Ultramarine Blue. Warm primaries include Cadmium Yellow Medium, Cadmium Red Light and Cerulean Blue.

Yellow Grey, Rose Grey and Monochrome Tint Warm are optional. Other colors not shown that are helpful to have are Payne's Gray, Lemon Yellow, Phthalo Blue and Ivory Black.

Laying out colors in a line makes it easier to pick up a little of one color without messing up the rest.

sampler of different canvas board surfaces to try. This is a good way to test them and find your favorites.

Generally, I buy stretched and acrylic-primed canvases for convenience, but I stretch my own on occasion. I sometimes use linen canvas for commissioned pieces.

Palette Knives
These are two palette knives I use. One has a 3-inch (8cm) rounded edge, and the other has a 2-inch (5cm) angular shape.

Mongoose and Sable Brushes
Mongoose and sable brushes are softer than bristle brushes. They're useful for applying paint over a very wet coat of paint, because a soft brush is less likely to lift up the layer of paint underneath. Shown here is a sampling of mongoose and sable flats, filberts, brights and rounds. Three or four brushes ranging in size from no. 2 to no. 20 are enough to start with.

Bristle Brushes
Start with a good variety of bristle brushes: three or four filberts, ranging in size from no. 2 to no. 18 and at least one flat, 1 inch (25mm) or wider for larger areas. The bristle brushes shown here are from top to bottom, a 2-inch (51mm) flat, a no. 12 filbert, a 1-inch (25mm) flat, a ¾-inch (19mm) flat, and nos. 8 and 4 filberts.

small tin can and placing the can upside down in a jar, but be sure the jar has an airtight lid to prevent spills and leaking fumes.

- **Cotton rags or paper towels.**
- **Pliers or nutcracker** to loosen caps on paint tubes.
- **Razor blade** for scraping dried paint off your palette.
- **Sketchbook.**
- **Vine charcoal** for drawing on canvas or board, if you prefer not to draw with a brush.
- **Camera** to take reference photos.

Studio Setup

My studio easel is a Sithia's Taboret & Easel. It is durable and just the right size for my small work area. It holds up to a 44-inch-tall (112cm) canvas. It has wheels and lots of storage space, and it can tilt forward. The top drawer is a great place to put my palette if I don't want to hold it.

A rear projection screen is useful for displaying reference slides without glare from lights or a window. I keep the projector 8–10 feet (2.4–3 meters) behind the screen, which is beside my easel for easy viewing.

Working in indirect daylight from a north window is preferable, but when I can't do that I use Chroma 50 fluorescent bulbs, which approximate daylight. I use these bulbs overhead and on either side of my north window. I also have track lighting down the center of the ceiling, and I had an electrician wire my lights so I can turn on each one individually.

Plein Air Setup

Be prepared to paint outdoors, a process that's very educational, rewarding and humbling at the same time. The experience can't be beat. Additional materials you will need for painting en plein air include:

Mineral Spirits or Odorless Thinner

Use one of these with oil paint to tone your canvas. They also get paint out of brushes; do this between colors and at cleanup. Follow up with a brush cleaner and conditioner or mild soap and water.

Medium

Use nonyellowing oil medium such as Winsor & Newton Liquin to facilitate the glazing and spreading of paint. When mixed with paints or applied in a thin layer on dry paints, oil medium hastens drying time: it usually makes paint dry to the touch in twenty-four hours.

Varnishing your painting is a good idea to protect it and to bring out the richness of the colors, but an oil painting must dry for six to twelve months before it can be varnished. In the meantime, after a painting is completed and dry, I apply a thin coat of medium all over it to give it a glossy, varnished look.

Other Materials

The following will come in handy:

- **Small palette cup with a screw-on lid** to hold oil medium.
- **Brush holder.**
- **Brush washer.** The airtight, nickel-plated steel ones are perfect. A coil or shallow perforated tray in the bottom provides a place to drag the bristles and loosen paint. You can make your own brush washer by punching holes in a

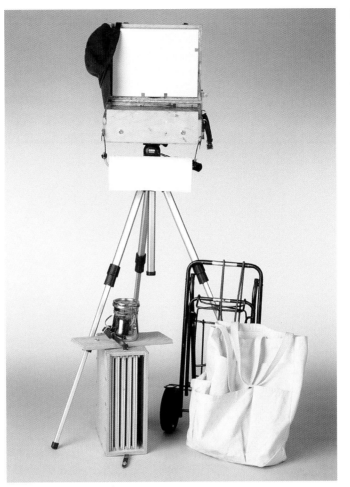

- **Portable easel or pochade box, preferably lightweight**. I use the Guerrilla Painter Pochade TravelBox. This rugged, oiled plywood box carries and protects two wet panels, paints, brushes and other necessities. It fits on a quick-release tripod mount and can be customized with many accessories. The box and carrying case accommodate all 9" × 12" (23cm × 30cm) materials.
- **Canvas carriers.** These are a must. The carriers are wooden and have slots inside to keep your wet canvases separate. They come in different sizes; the one pictured on page 12 is made for 9" × 12" (23cm × 30cm) panels.
- **Cart.** A luggage cart comes in handy for transporting supplies. It has bungee cords for strapping things down. (If you plan to hike on difficult trails, a backpack with lots of compartments would be a better choice.)
- **Cloth field bag**. These are generally made of cotton and have lots of pockets and space to carry an abundance of supplies. They can be found in art stores, art catalogs and garden centers.
- **The right clothing.** Wear dark clothes that won't reflect their color onto your canvas. A hat is essential for shading your eyes so you can see your subject and your painting. A baseball cap will do this and is easy to pack.
- **Umbrella.** When you can't work in a shady spot, use an umbrella to make shade. Whether you choose the kind you pound into the ground or one that clamps onto your easel, make sure it shades you and your canvas.
- **Camera.** Use this to gather photo references for details you want to address back in the studio. You may need photos if a storm forces you to quit painting suddenly. I always take a shot right before starting a painting to capture the reason I was drawn to the scene. Sometimes I take a shot after the light has changed; I may decide the mood is better in the later photo.
- **Viewfinder**. A viewfinder isolates and simplifies the scene in front of you. You can use something as simple as a 35mm slide mount or as elaborate as a commercially available viewfinder with built-in compositional guides and red filters to help you see values. A camera with a telephoto lens also works well as a viewfinder since you can zoom it in and out.
- **Sunscreen**.
- **Bug spray.** Don't get distracted by pesky mosquitoes, flies or bees. If you choose a sunscreen with bug repellent in it, you'll have one less item to carry.
- **Water bottle**.
- **Trash bag**. Use this to hold used paper towels and any other trash. Plastic grocery bags are great for this; their handles conveniently hook onto an easel.
- **Moist wipes**. Use them to clean your hands and anything else you may have gotten paint on.

TIP

When painting on the road, I use toned canvas cut into small pieces. I clip them to a board on my easel. I hasten the drying time by adding Liquin to the paint or using a quick-drying white. Then I can transport the canvases home in a plastic tube for later stretching or mounting. A lot of these are studies for future paintings.

PAINTING TECHNIQUES AND THE BASICS OF MIXING COLOR

It's been said that if you always try to paint like someone else, you can only be second best. As your skills increase, you will combine knowledge gained from each of your instructors, but you will develop your own style.

But before you set out to do your own thing, it pays to learn the basics. This chapter will explain the oil painting process and teach you a variety of brush techniques. You'll learn about mixing colors, using value and color temperature, and choosing colors that communicate a mood. Painting is really a matter of getting the right value of the right color in the right shape with the right edges. Practice the basics in this chapter, and you'll be well on your way to a technique that works for you.

A Summer Place • *Oil on canvas* • *16" × 20" (41cm × 51cm)*

Toning the Canvas

Throughout history oil painters have worked on a toned ground. There are many advantages to using a toned canvas:

- Toning the canvas can speed the painting process. A midvalue background tone can suffice for the middle values in a quick study, so you just have to put down the darks and lights.
- A toned canvas can help you judge colors and values accurately. The glare of a white canvas can make your colors appear darker than they really are.
- The base tone often shows through the painting in spots, which can help set the painting's mood and enhance colors laid on top. For example, a coral tone peeking through can add to the mood of a blue sky or create a nice contrast to green trees.

You can tone cotton or linen canvas by priming it with acrylic gesso. The recipe on this page will make 10 to 12 fluid ounces (296ml to 355 ml) of toned primer, enough to prepare several canvases, depending on their size. You can store toned primer for several months in a plastic container with a lid.

MATERIALS

ACRYLICS—FOR A CORAL TONE
8 fl. oz. (237ml) white gesso primer • 2 fl. oz. (59ml) Cadmium Red or Naphthol Red Light • 2 fl. oz. (59ml) Yellow Ochre

ACRYLICS—FOR A GRAY TONE
8 fl. oz. (237ml) white gesso • 1 fl. oz. (30ml) Burnt Umber • 1 fl. oz. (30ml) Ivory Black

SURFACE
Acrylic-primed canvases or panels

BRUSHES
3-inch (76mm) house-painting trim roller or an inexpensive house-painting brush

OTHER MATERIALS
12-ounce (355ml) jar or other container
Paint-roller tray
Very fine sandpaper

1 Mix the Toned Primer
Pour white gesso primer into a container. Do not add water. Decide whether you want a coral tone or a gray tone, then thoroughly mix in the appropriate acrylic colors shown in the materials list. Pour the mixture into a paint-roller tray.

2 Apply
Using a 3-inch (76mm) house-painting roller or brush, spread the toned primer onto acrylic-primed canvases or panels. Apply thinly but with enough coverage to hide the white of the surface—you shouldn't have little white spots showing through. Wash the roller or brush in cool water. Allow the canvases to dry completely (about three hours).

3 Sand
After the surface has dried, sand it lightly with very fine sandpaper. Now it is ready to be painted.

The Oil Painting Process

The basic process for oil painting is the
same whether you're painting a landscape,
a still life or a portrait.

1 Plan and Draw the Composition
Plan the design and make sure everything will fit as you want it to. In studio paintings you can plan ahead by doing thumbnail sketches, but when painting en plein air, you must capture a fleeting moment. Have an idea in mind and go for it.

On a toned canvas, draw the subject without too much detail. This should be quick unless the subject has complicated architecture. You can draw with a piece of vine charcoal (a thin, very soft charcoal which is available at art supply stores) or with a brush and an earth tone oil color, such as Burnt Umber.

If you use a brush to draw, a filbert bristle works well because of its tapered end. Dip the brush in mineral spirits, then use a paper towel to wipe off the excess. Use very little paint on the brush. If you apply too much paint the sketch will be too wet for the next step.

2 Lay In Shapes
Lay in simple shapes. Think of your subject as a puzzle, and assign one main color (the local color or the predominant color) to each "piece." Mix a color and apply it to its shape; do this for all the shapes until the canvas is covered.

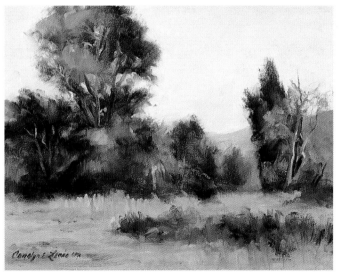

3 Divide the Masses
To finish the painting, and break down each piece of the puzzle into the shapes and values within. After this is done, add details if necessary.

Brush Techniques

Brushes are available in various shapes and sizes. Experiment with some of the following brushes and brushstrokes, and decide what's best for your style of painting.

Practice Different Brushstrokes
Get a feeling for what different types and sizes of brushes will do for you and your style of painting.

BROKEN COLOR

Broken color means different colors laid down next to one another but barely mixed. The viewer's eye "mixes" the colors. Broken color makes for wonderful atmospheric effects for fog and gray skies.

Short, horizontal brushstrokes made with a no. 10 sable bright

A vertical continuous stroke made with the side of a no. 4 ox hair filbert

Fine lines made with a no. 6 sable round

Large brushstrokes made with a no. 6 ox hair flat

Random Brushstrokes
Random brushstrokes break up flat, uninteresting areas. Oil paint's natural thickness gives texture and works well with random strokes to blend colors loosely.

Smooth, Long Brushstrokes
Smoother, longer and more transparent brushstrokes can be achieved by thinning paint with spirits or medium.

Directional Brushstrokes for Structure
With directional brushstrokes, you can convey the structure of objects such as buildings.

Directional Brushstrokes for Growth
Directional brushstrokes can show growth for grasses, shrubs and the like.

Scumbling
Scumbling is a method of using a little paint on a brush and rubbing it across the canvas. This creates a layer of color that allows the color underneath to show through.

Crosshatched Brushstrokes
Crosshatched brushstrokes are made with short brushstrokes that cross one another. To achieve broken color (see sidebar above) with cross-hatching, use thick paint and mix the colors on the canvas, not on the palette.

Painting With a Palette Knife

Probably the most common use for a palette knife is to pick up colors to mix with other colors on a palette. However, paintings can be done with a palette knife alone or combined with brushwork for varied textures.

SCRAPING WITH A PALETTE KNIFE

Scraping with a palette knife is useful for removing wet paint so that you can apply new color cleanly, without unwanted color mixing. You can also use this scraping method to clean your palette.

To scrape, hold the forward edge of the palette knife downward against the canvas or palette and drag with light pressure across the surface where you want to lift off most of the wet paint.

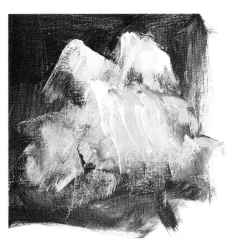

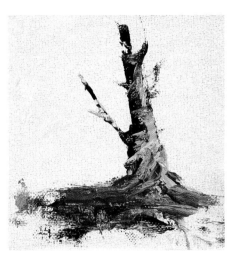

Spreading Paint
Pick up paint on the flat bottom of the knife and then make a stroke with light pressure. Gently lift the forward edge of the knife's blade as you spread the thick paint from beneath.

Adding Detail
Palette knives are great for rendering detail. Suggest trees, branches and building edges by using only the blade's edge. Pick up enough color, then tilt the blade on its edge. By pushing and pulling the knife with light pressure, you can achieve a series of sharp, thin lines.

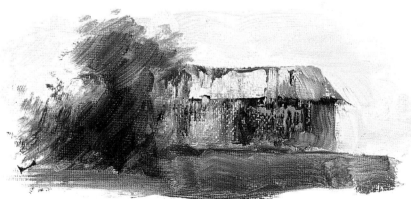

Lost and Found Edges and Blending

Edges are boundaries between color areas. You can be make them soft (fuzzy), moderate, hard (sharp) or lost (blended between objects). If edges are handled well, the image will be convincing. This can be difficult, but there are ways to make the job easier.

First, practice seeing edges and values by studying the world around you. Try squinting to see values. Adjacent shapes that are close in value seem to blend together. Some objects, such as clouds or grasses, have soft edges, while others, such as structures and rocks, have higher contrast and sharper edges.

Second, remember the effects of atmosphere and light conditions. For instance, on a cloudy or overcast day, edges look diffused. In hazy and foggy conditions, edges of things in the distance are very subdued. On the other hand, if it's a sunny day, edges appear sharper.

Third, think about movement. Imagine a flying bird. Your eye would not record every feather. If you were to paint the bird with every feather in place and not blur the edges of the wings, it would lack a feeling of movement and look pasted on the canvas. Another example is a large spray of water hitting rocks. The water continuously moves, so it would be wrong to paint it as if it were still.

Soft Edges Suggest Fog
Make soft edges like this for a foggy day by limiting the contrast. Crosshatched colors can help create the proper effect. Start with the sky; while the paint is still wet, work your way from background to foreground. Remember, even though it's foggy, you can still see the edges; they are just not highly defined.

Morning Fog (Study) • *Oil on canvas* • *6" × 8" (15cm × 20cm)*

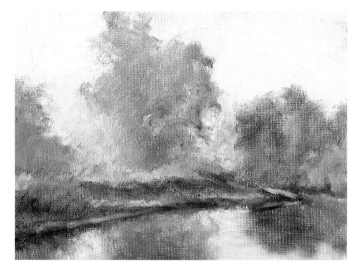

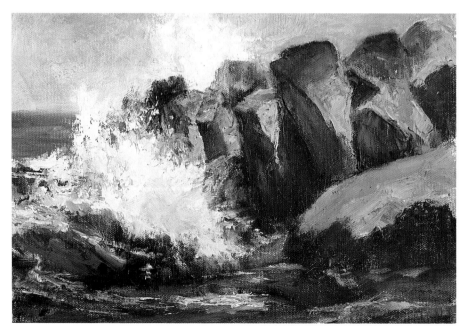

Hard Edges Indicate Bright Sun
On a sunny day, light and shadow produce contrast. The rocks in this study have hard edges, while the waves splashing against the rocks have softer edges, bringing movement and energy to the painting.

Using a palette knife to lay in the rocks gives them texture thatmakes them more realistic. Also, the wave is laid in with some palette knife strokes on the top to get more texture and opacity.

Ocean's Fury (Study) • *Oil on canvas* • *9" × 12" (23cm × 30cm)*

The Properties of Color

To depict mood and atmosphere in a painting, you must be able to mix a wide range of colors. Understanding the basic properties of color is essential. Practice mixing the colors shown in the color wheel.

The Basic Hues

The outside ring of the color wheel shows how primary colors mix to form all other colors.

Color Temperature

A color's temperature is its apparent warmth or coolness. In this color wheel, the left half contains colors we perceive as warm, and the right half contains cool colors.

Color temperature conveys a feeling of cold or warmth. Because of this, the predominant color temperature in a painting greatly impacts the mood a painting conveys to the viewer.

Tints, Tones and Shades

The inside rings on the color wheel demonstrate what happens when you mix white, gray and black with each of the basic hues to produce tints, tones and shades, respectively. Adding white lightens and cools the original color. Adding grays makes colors less intense and may change the value. Adding black makes a color darker but not necessarily richer.

Complementary Colors

Complementary colors are those opposite one another on the color wheel. Complementary colors used close to each other in a painting tend to intensify each other. Mixing complements produces various shades of gray, and a bright color can be toned down by adding a bit of its complement.

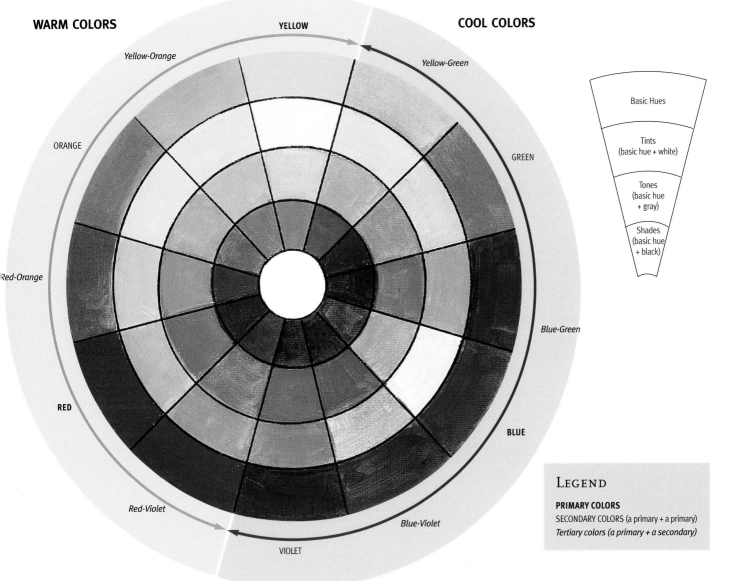

WARM COLORS

YELLOW

COOL COLORS

Yellow-Orange

Yellow-Green

ORANGE

GREEN

Red-Orange

Blue-Green

RED

BLUE

Red-Violet

Blue-Violet

VIOLET

Basic Hues

Tints
(basic hue + white)

Tones
(basic hue
+ gray)

Shades
(basic hue
+ black)

LEGEND

PRIMARY COLORS
SECONDARY COLORS (a primary + a primary)
Tertiary colors (a primary + a secondary)

Color Mixing Challenges

Tube Grays vs. Mixed Grays

When it comes to tube grays vs. mixed ones, either way works—do what's comfortable for you. I usually have some tube grays on my palette because they are convenient. If you paint a large area of gray, starting with a tube gray and adjusting it with a little color is speedier than mixing a gray—speed is especially important when you outdoors. If a color you are using needs to be toned down, you may find it easier to add a touch of tube gray than to use the color's complement; the gray has less chance of changing the color or value too much. Beginners especially may have trouble toning with complements and may waste paint working back and forth trying to get the correct color.

GREEN GRAY
White + Sap Green +
Cobalt Blue

**MONOCHROME
TINT WARM**
White + Yellow Ochre + Olive Green

BLUE GRAY
White + Cobalt Blue +
Ivory Black

VIOLET GRAY
White + Permanent Rose
+ Cobalt Blue

ROSE GRAY
White + Alizarin Crimson +
Olive Green

YELLOW GRAY
White + Yellow Ochre + Violet
(violet made of White + Alizarin
Crimson + Ultramarine Blue)

MIDDLE VALUE GRAY
White + Ivory Black +
Burnt Umber

WARM GRAY
White + Terra Rosa +
Cadmium Yellow
Medium + Alizarin
Crimson

Mixing Grays

Try mixing these grays. The results depend on how much of each color you use. The bottom half of each swatch has more white mixed in so you can see two different values of each gray.

Two Ways to Mix Tones

Toning (using gray to reduce the intensity of a color) can be done by adding a complementary color or a tube gray. Here, I've blended yellow, orange and red with their complements to produce grays in the middle. Underneath each complementary blend, I've mixed a middle-value tube gray into the yellow, orange and red.

Greens

Mixing greens that aren't garish takes practice. Students usually have problems mixing greens, so sometimes I let my students start with three tube greens: Olive Green, Sap Green and Viridian.

Learning to mix your own greens has its advantages. Being able to mix the greens you need from red, blue and yellow reduces the number of colors you need on your palette, which is particularly convenient when painting en plein air.

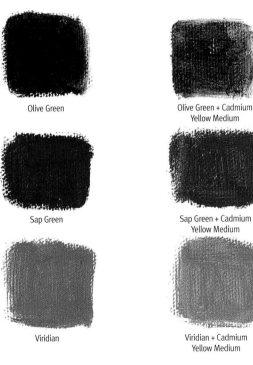

Olive Green

Olive Green + Cadmium Yellow Medium

Olive Green + Cadmium Yellow Pale

Sap Green

Sap Green + Cadmium Yellow Medium

Sap Green + Cadmium Yellow Pale

Viridian

Viridian + Cadmium Yellow Medium

Viridian + Cadmium Yellow Pale

Ways to Modify Tube Greens

You can modify tube greens for a greater range of values and temperatures. Try mixing each of these greens with a warm yellow such as Cadmium Yellow Medium for a warmer tone and a cool yellow like Cadmium Yellow Pale for cooler greens.

Color Schemes

Using a color scheme brings color harmony and freshness to a painting. Try some quick studies like the ones shown here, and save your studies as reminders of how to achieve color harmony in your paintings.There are five basic types of color schemes:

Monochromatic: One color used in various values created by adding white, black or neutral gray.

Analogous: One primary color plus about three adjacent colors in either direction around the color wheel.

Triadic: Three colors spaced about evenly around the color wheel. The colors in a triadic scheme don't have to be primaries; they can be subdued or high-key colors. Keep one color dominant in the composition to allow the painting to make a statement and communicate a mood. Using all the colors in equal quantities makes a painting weak and uninteresting.

Complementary: Two colors opposite each other on the color wheel. You can mix complements to get a subdued look, or you can use variations of the colors. As with a triadic scheme, be sure to let one color dominate.

Split Complementary: Similar to a complementary scheme, except that instead of using the complement of the first color, it uses the two colors immediately adjacent to the complement.

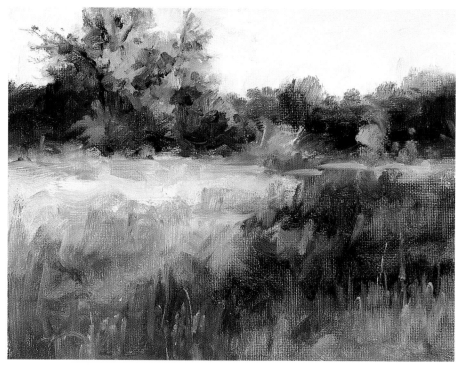

Monochromatic Study
Painting a monochromatic study is an excellent lesson in value relationships. I began this one with a yellow-green, then simply added white and black to create a summer scene.

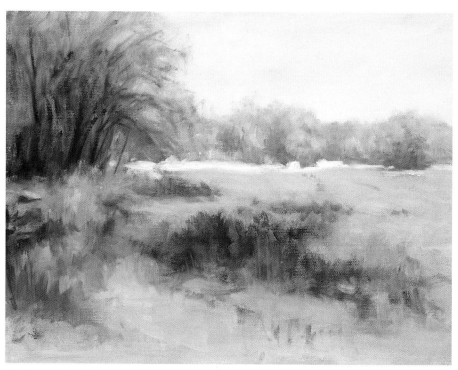

Analogous Study
Analogous colors can effectively communicate the season and mood of a landscape. I used a cool analogous theme for this study: blue, blue-violet and violet. I stretched the scheme by bringing in a red-violet.

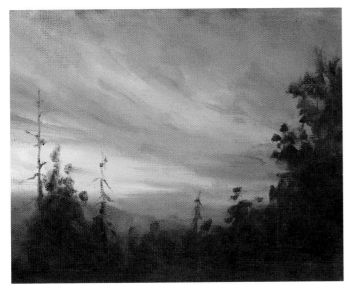

Triadic Study

Here, I used all three primary colors and made blue the dominant color.

Complementary Study

In this study using complementary colors, green and its variations are dominant while red, green's complement, is subordinate. The contrast of all that green against the touch of red I used for the flower sets off the focal point.

Split Complementary Study

In this study I used violet, yellow-orange and yellow-green, which are yellow's complement and adjacent colors, respectively.

Seeing Color

Factors Affecting Local Color

Local color is the actual color of an object, yet color is all about perception. I'm convinced that each of us sees color a little differently.

Local color—for example, the red of an apple, the green of grass, the white of snow—varies depending on the quality of the light. Is the object in shadow? Are the colors of nearby objects reflected onto it? To create believable paintings that capture mood and atmosphere, you must be able to forget local colors and learn to see colors as they really appear.

Practice Observing Color

To learn what factors affect perception of color, place an object outside where you can observe it over several days and at different times of the day. Notice how the apparent hue, value and intensity change depending on the quality of light on a given day. For example, on a sunny day, the colors of the object will have more contrast, with the lights lighter and the shadows darker. On a cloudy or foggy day, the light is softer and the contrast of the object's colors is less evident. At noon everything is lit from the top, while in late afternoon or early evening the shadows are long and the light has a wonderful warmth to it—that's why artists like painting in the early morning or late afternoon. Moonlight produces cooler colors.

Bring that object inside and observe it under different indoor lighting conditions. Natural light from a window differs from the tungsten light from a lamp. The colors of nearby objects may reflect onto your object, changing its appearance.

Learn to See Color in Reference Materials

I use slides as reference material in the studio, though I have to compensate for the imperfections of this setup. I know a painting can't duplicate the luminosity of a slide projector. Also, the bulbs used in a projector are usually a different color temperature than the room lights in a studio. I still prefer slides over photos for reference because colors are richer in a transparency. The trick is knowing how to compensate for the camera's imperfections, which we will discuss in chapter five (see page 102).

TIPS FOR VIEWING LOCAL COLOR OUTDOORS

- Wear a hat that covers your eyes. Direct sunlight will cause your pupils to constrict, making it harder to see color. Squinting is good for simplifying details and seeing values and edges, but if you squint all the time, you will see less color.
- Wear dark clothing. This may be hot in the summer, but the colors of dark clothes won't reflect onto your canvas.
- Keep the palette and canvas in the same light. I try to stand in the shade, if that's not possible, use an umbrella to cover both you and your palette. If you paint in bright sunlight, the colors on your palette will seem lighter than they really are and you'll mix them accordingly. When you bring the painting indoors, it will likely be too dark.

Values and Their Relationships

Value is the relative lightness or darkness of a color. Since we can't paint light itself, we must use values to paint the effects of light.

In painting, we use a value scale as a guide. A value scale of about ten steps represents what we actually see, but in a painting, more than five values is probably too many. Using too many values makes a painting busy; the eye doesn't know what to focus on.

Make a Value Plan

Painting is all about visual relationships. When you plan a painting, think of three values: light, middle and dark. You may actually use five values, but these three provide a good way to start thinking about the relationships of one value to another.

Always do a value sketch or thumbnail sketch before you start painting. The planning begins here and this process can spare you a lot of problems while you paint.

When you make the value sketch, choose the painting's key. A high-key painting contains white plus the light halftones on the value scale. A low-key painting uses the dark halftones. If you choose to use both high key and low key, make sure one key dominates.

Use Value to Create Depth

There are usually three or four planes of value to consider. With the exception of snow in sunlight, the sky is always the lightest plane in a painting. Horizontal surfaces, such as the ground, have medium-light value. Slanted objects, such as roofs and hills, have medium-dark value. The darkest values usually fall on vertical objects, such as the sides of buildings and trees. As objects recede, they generally get lighter due to atmospheric conditions and have less value contrast. Exceptions have a background darker than the foreground—a cluster of dark pines with a sunlit white building in front of them, for instance.

When starting a value sketch, first establish your lightest light and darkest dark. Everything else will fall somewhere in between these. Always compare values as you put down new colors, because if the value isn't right, neither is the color. Strong value contrasts attract attention, so reserve these for your focal point.

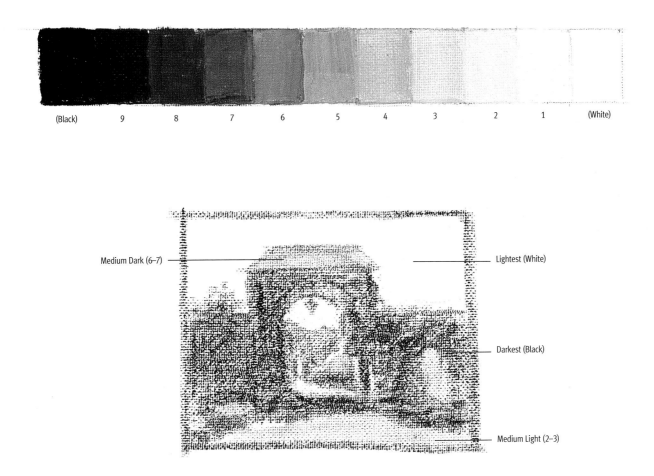

| (Black) | 9 | 8 | 7 | 6 | 5 | 4 | 3 | 2 | 1 | (White) |

Medium Dark (6–7)

Lightest (White)

Darkest (Black)

Medium Light (2–3)

Color Temperature

Color temperature is instrumental in creating mood. Cool colors, such as blues and blue-violets, suggest peace and serenity; warm colors, such as yellows, oranges and reds, evoke feelings of warmth and excitement.

Light Temperature

The temperature of the light source contributes to the mood of a painting. If you have trouble determining the temperature of a light source, remember this: With very few exceptions, if the shadows are cooler than the lighter areas of the painting, the light source is warm; if the shadows are warmer than the lighter areas, the light source is cool. After you figure out whether the light source is warm or cool, you can determine what temperature the local colors should be. Everything should be harmonious if you stick to the temperature relationships throughout your painting.

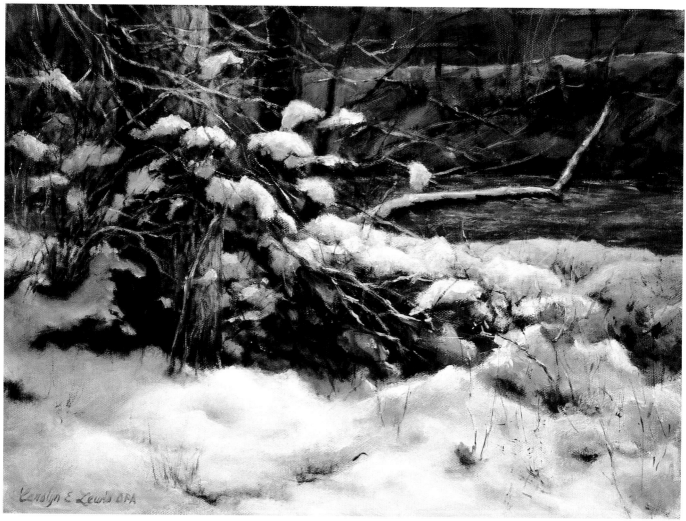

Cool Colors Create a Wintry Mood

In this winter scene, the light source was warm, so the shadows are cool. I used mostly blues, blue-greens and white. The orange in the leaves is a complementary accent. This was the last snow of spring, and I wanted to capture the puffy, sunlit snow that formed on the branches before it melted into the rushing river in the background.

Cascade Winter • Oil on canvas • 12" × 16"(30cm × 41cm)

Pigment Temperature

Pigment temperature is how warm or cool a color looks compared to the colors adjacent to it. For instance, a violet compared to orange seems cool, but the same violet seems warm when compared to blue.

Mix the Color Temperature You Want

If you know the temperatures of the colors on your palette, mixing to achieve the desired color temperature is fairly simple. Say you want to mix a cool yellow-green. You could start with Cadmium Yellow Pale, a cool yellow. Next, add a small amount of Viridian, a cool green. If your mixture is not light enough, add some white. White will lighten the color and cool it as well. Learning to mix color takes practice. Remember that if you make a color-mixing chart for the paints on your palette (see page 23), you will have a handy reference.

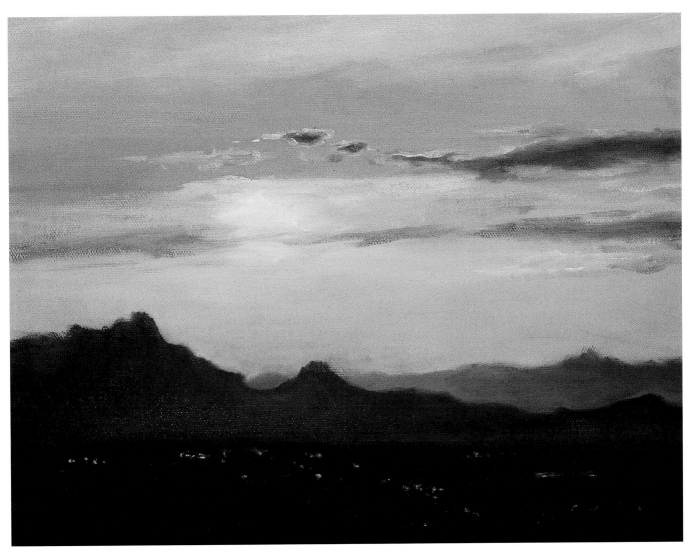

Evening Light May Call for Warm Colors
This painting, although a night scene, conveys warmth due to the colors used: yellow, orange, red, warm violets, and Cerulean Blue.

Arizona Sunset • Oil on canvas • 16" × 20"(41cm × 51cm)

Carolyn E Lewis OPA

PLAN A STRONG COMPOSITION

Composition is the art of forming a harmonious whole out of different parts. While the term *design* is often used synonymously, I believe *design* refers to the sketch or blueprint of an idea one wants to execute. The design is the further refinement of a composition.

This chapter will give you good grounding on topics such as focal point, balance, harmony, line direction, values and rhythm. Before you paint a scene, think about the reason you first were drawn to it. Decide what your focal point will be. Compose the painting in a way that will get your viewer's attention and direct the eye to the focal point. Then keep the focal point in mind all the way through the painting.

Denali · Oil on canvas panel · 9" × 12" (23cm × 30cm)

Simplify Complex Shapes

Beginning artists often want to paint every little detail. For example, they're tempted to paint every leaf and twig on a tree in the distance. This is the error of painting what you know rather than what you see. For a better painting, keep things simple—the viewer's mind will fill in the blanks, the details.

If you are just beginning to paint outdoors, consider these tips:

- Choose simple arrangements, and try to see the landscape in big masses of light and dark. A large convincing painting can be made by using a few masses, values, lines and color. Leave complicated scenes for the future.
- Lay in the basic shapes first. Do not think about detail at this stage. It's been said that the first half hour of a painting makes or breaks the painting. Establish a strong foundation of basic shapes first; worry about detail later.
- Define one focal point, and resist the temptation to paint unimportant details that will distract the viewer from the focal point. Everything should be subordinate to the focal point.

Too Busy
This is an example of a busy painting. There are too many clouds and too many patches of snow. The viewer can't tell where to look first.

A Simple Study
This study combines many small shapes into a few larger ones. These simplified shapes make a more organized, pleasing image.

How to Approach a Painting

Choose the Focal Point

Before you start a painting, first decide what attracted you to the scene—its color, mood, textures, contrast or weather effects. Then use some sort of viewfinder to focus in on the most important thing in the scene. Take the time to find the best possible view for a pleasing composition.

If the sky drew your attention to a scene, then compose your painting so that the sky takes up more than half of the canvas. If the ground area interests you the most, then paint less sky and more ground. What takes up most of the canvas is not necessarily the focal point, however. For example, a sky that takes up most of the canvas can be a mood-setting backdrop for what's in front of it.

If you have a busy or dramatic sky, keep the rest of the painting simple, and vice versa. To give the viewer a chance to concentrate on the center of interest, provide some restful areas.

If you depict more than one interesting area in your painting, decide which one will be dominant, and keep the other one subordinate.

Decide Where to Place the Focal Point

The focal point is what your viewer should notice first. If you remember only one thing about where to place the focal point, remember the "tic-tac-toe principle"—my favorite compositional guide. Imagine a tic-tac-toe board on your canvas, and place the focal point at one of the four points where the lines intersect. Some paintings break this rule yet hold up as strong paintings, but the tic-tac-toe principle is effective.

Do thumbnail sketches to test various locations for the focal point. Try vertical and horizontal layouts. Move things around for better placement. Remove

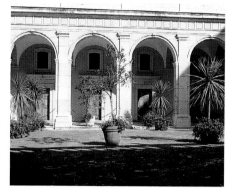

Reference Photo

things that aren't needed; keep only what will benefit the composition. It is better to make mistakes during this sketching process than after you've spent hours painting.

Use Line, Color and Value to Emphasize the Focal Point

Plan your compositional lines, colors, values and edges so that they emphasize the focal point. Here are some ways to do this:

- Create directional lines and movement that lead the eye to the focal point.
- Paint the sharpest edges at the focal point.
- Let the greatest amount of value contrast happen at the focal point.
- Place the brightest colors at the focal point.

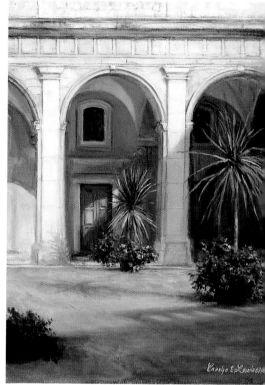

Finished Painting
Be selective about the elements of a reference photo you use in your painting. Leave out objects that aren't necessary to tell your story. Here, I decided focusing on a single door would be more effective than letting several doors fight for attention.

Monte Cassino • *Oil on canvas* • *16" × 12" (41cm × 30cm)* • *Private collection*

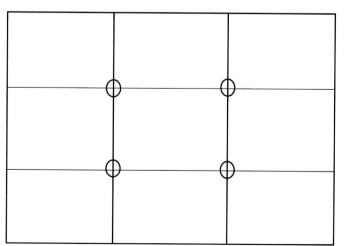

The Tic-Tac-Toe Principle
A classic compositional method is to mentally divide a painting with a four-line grid, then place the focal point at one intersection of the lines.

Express Mood With Values

Well-defined, unbroken, contrasting values make a powerful statement. The fewer values, the better; too many will make the painting busy. Some tips for planning values:

- Keep three values in mind: light, middle and dark.
- Let one of these values be dominant in the painting.
- You may choose to add very bright reflected light as an accent, but use it sparingly.

Simplifying your values in this way will have the effect of simplifying your shapes, which makes for a stronger painting.

The values emphasized in your painting have much to do with the mood your painting sets for the viewer. A low-key painting of a rainstorm at the beach will create a much different feeling than a high-key painting of the same beach on a sunny day. Use a strong value plan to help the viewer feel as if they were present in your landscape as it was being created.

Late-Afternoon Painting

I was on my way into Aspen, Colorado, when I saw this meadow. I was drawn to this scene by the three trees catching the light of the late-afternoon sun. I set up in the middle of the meadow and painted very quickly. I wanted to capture the warm sun hitting the main tree and casting that tree's shadow on the tree left of it. This dark-value shadow brings out the intense yellow on the main tree. The long shadows suggest that night is approaching and create a sense that the warmth of this fall scene will soon be replaced by winter.

Aspen Meadow · *Oil on canvas panel · 9" × 12" (23cm × 30cm)*

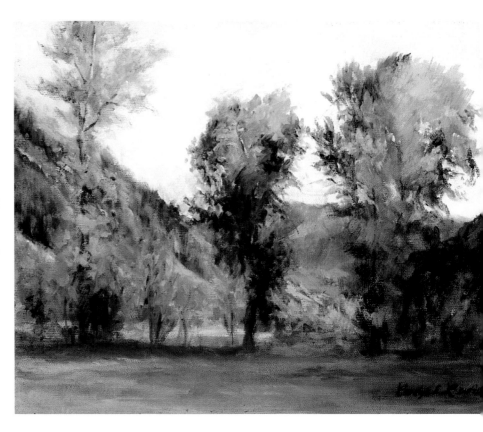

Change Values to Increase the Drama

To make the best possible painting, artists sometimes have to invent things by introducing more contrast, toning things down or changing a color temperature. This is called artistic license. I like to think of it this way. The creator of a work has the responsibility to make the best work he or she can.

This painting of Palatine Ruins was done after a trip to Italy. This was a late-afternoon painting but the sunlight wasn't directly on the subject. I contrived some sun by creating shadows. The value changes I made on the foreground, up the steps and at the top right give the painting more interest and drama.

Reference Photo
The light was pretty even when this photo was taken. I needed to add some drama by increasing the value contrast.

Use Artistic License When Necessary
The shadow across the upper-right corner makes the viewer's eye go to the focal point, at the top of the steps.

Palatine Ruins • *Oil on canvas* • *20" × 16" (51cm × 41cm)*

Choose Expressive Color

An artist's color choices set a mood and create a subconscious emotional reaction. A color scheme helps communicate your feeling about a scene to the viewer. Using a color scheme also encourages you to paint with a somewhat limited palette, which will in turn lend harmony to your painting.

The colors you observe in a scene might create a wonderful color scheme as is. But if you think the color scheme would be stronger with a change in color or temperature, go ahead and use your artistic license to make your painting the best it can be.

When you react to a beautiful sunrise or sunset or see complex colors in heavy, wet snowfall that clings to each twig and branch—and you don't have your paints or a camera with you—try to memorize the colors by thinking of the colors on your palette.

Even when you must work from a photo reference, think about what it was like when you were standing there taking in all the beauty of a scene. Try to relive the feeling of that experience, then convey that feeling in your painting. I call this painting with passion. I'd rather see a painting done with passion than a methodically painted one that feels cold and lifeless.

Capture the Feeling of Bold Color
The color of this ground cover—called ice plant—was so vivid I had to paint it. The sheer quantity of the plant in one place along a walking trail in Carmel, California, was breathtaking. The purple is all the more striking against the complementary yellow tones in the landscape.

Pacific Grove Ice Plant · *Oil on canvas* · *12" × 16" (30cm × 41cm)*

High Key and Low Key

I like to define *key* in terms of a ten-step value scale. A high-key painting is one that contains only white and the three or four values nearest to white. A low-key painting uses the dark values at the other end of the value scale: black and its neighboring three or four values. Both kinds of paintings display reduced contrast since all the values are so close to one another.

Try painting a high-key study, then paint a low-key one. This will increase your awareness of the effects of value and color.

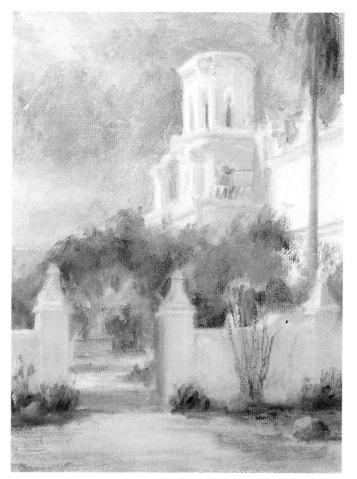

Painting in High Key

The San Xavier del Bac Mission in Tucson lent itself to this high-key study because of its white walls and the bright sunny sky.

High-Key Study • *Oil on canvas board • 8" × 6" (20cm × 15cm)*

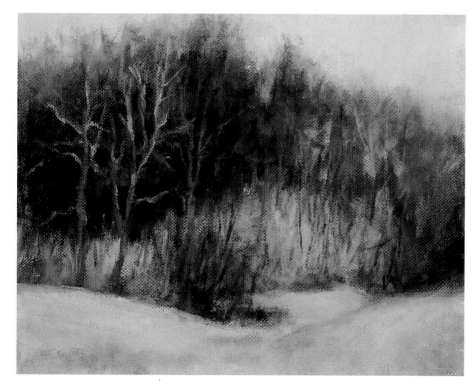

Painting in Low Key

This painting was done just before sunset at a snow-covered scene. The warm orange and sienna on the trees complement the bluish purple shadows in the snow.

Low-Key Study

Oil on canvas • 8" × 10" (20cm × 25cm)

Use Contrast to Establish the Focal Point

High contrast creates energy in a painting, while low contrast conveys a restful feeling. Squinting can help us see the contrast between values, but squinting also darkens values, so keep that in mind when you paint outdoors.

Value contrast is the most common form of contrast used to highlight the focal area. Other forms of contrast include bright against dull, warm against cool, and large shapes against small ones.

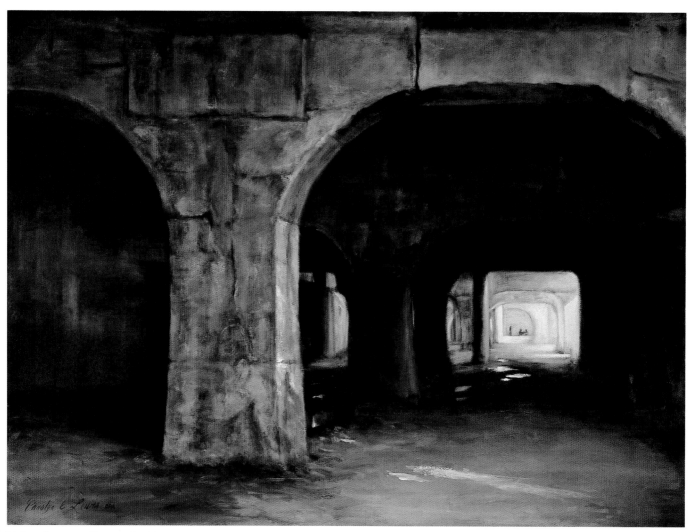

Value Contrast Draws the Eye

In this painting of the cavernous space under a road in Akron, Ohio, the lightest values and the focal point are far off in the background. I added just a few light accents in the puddles of water and on the ground to add interest and to lead the eye back to the focal point.

When I first saw this scene, I saw under the roadway a large empty box in which some homeless people had slept. However, when I came back, the box was gone and there were people having a picnic. This was a strange contrast of events.

Under State Street · *Oil on canvas* · *22" × 30" (56cm × 76cm)*

Choose a Vantage Point That Provides Contrast

In foggy or misty conditions, strong contrast may not be present. For a more effective composition, include in your composition a foreground object that can provide some contrast.

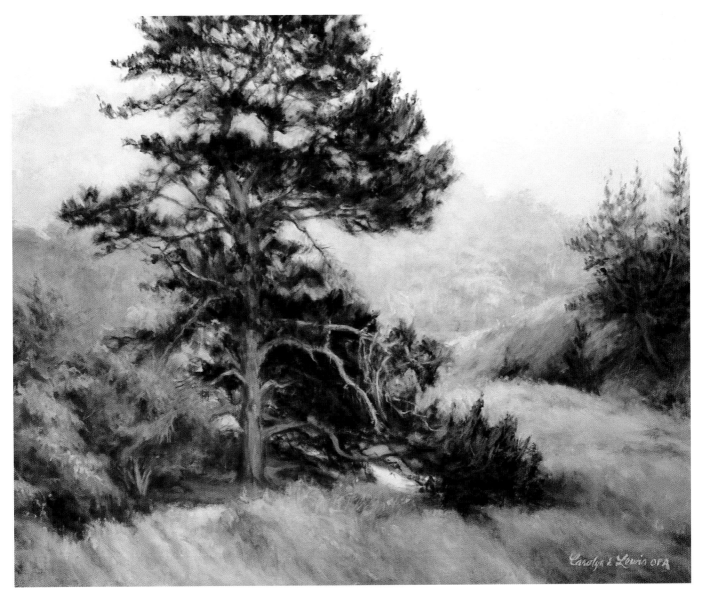

Seek Out Value Contrast

To ensure that this painting would have some contrast, I chose a scene with a dark foreground object, the tree, in front of the fog. The tree serves as the focal point.

Path to China Cove · *Oil on canvas* · *16" × 20" (41cm × 51cm)*

Warm Against Cool

Color temperature means how warm or cool a color looks. The eye generally perceives cool colors as receding, whereas warm colors appear to come forward. You can use temperature contrast to create depth and to highlight the focal point, as I did in the paintings on these two pages.

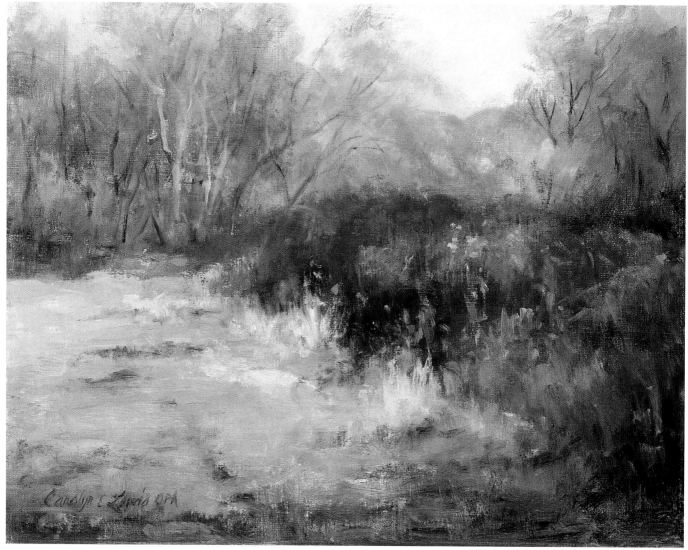

Use Cool Colors to Highlight a Warm Focal Point
In this scene I loved the contrast of the reddish brown bushes against the green field.
I kept the background hills cooler and used subtle colors for the background trees.
The cool background contrasts nicely with the warm reddish brown bushes, which are
the center of interest.

Fall Splendor · *Oil on canvas board* · *9" × 12" (23cm × 30cm)*

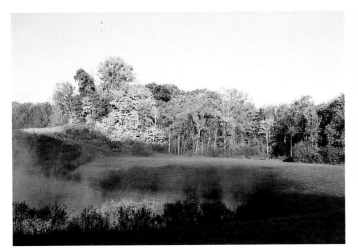

Reference Photo

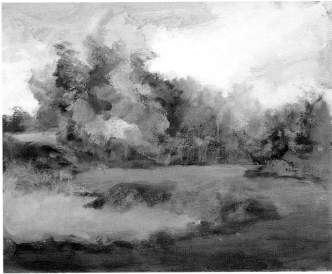

Study

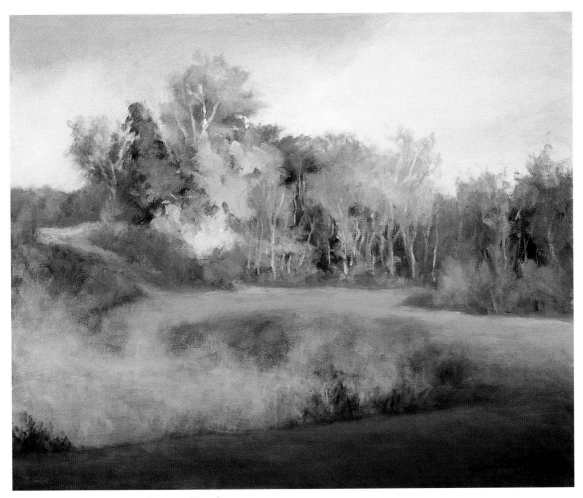

Temperature Contrast Enhances Mood

A sunny, cold, crisp autumn morning makes for exciting color and temperature contrasts. The cool shadows increase the intensity of the yellow foliage.

Indigo Lake · *Oil on canvas* · *16" × 20" (41cm × 51cm)*

Use Color Dominance to Create a Mood

You may look at a scene and decide that one of the colors you see should be dominant in the painting. Or you may decide to change the overall color scheme of a scene in order to evoke a certain season or mood.

Once you've decided what color will dominate your painting, you can mix that color in different values and intensities and use those variations throughout your canvas. This will create color unity and help create the mood you want to portray.

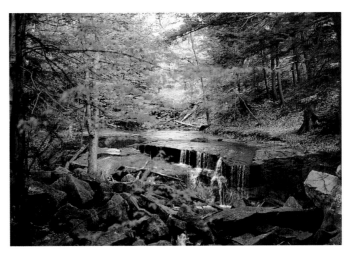

Reference Photo

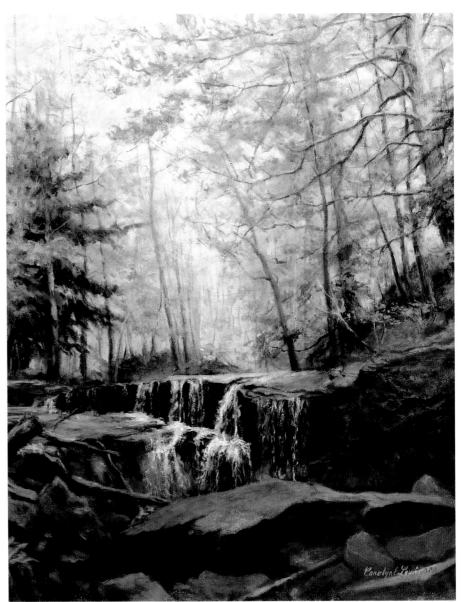

Color Choices Evoke the Mood of a Season

For this painting, I changed a summer scene to an autumn one by using more yellows to give it a glow and to convey warmth.

Virginia Kendall Waterfall · *Oil on canvas* · *24" × 20" (61cm × 51cm)*

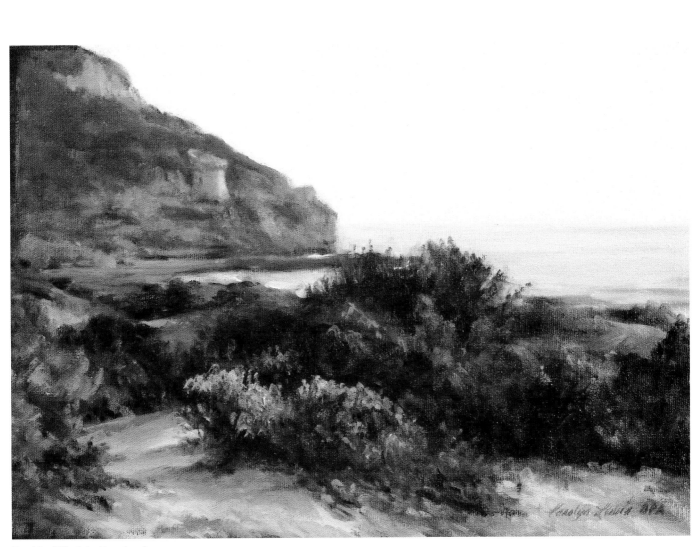

Decide What to Emphasize

Late-afternoon sun lit this Mediterranean shore in Italy. The colors of the flowers appealed to me, but so did the ruins of a castle structure in the background. One element had to dominate, and the beach and its colorful flowers won out. Greens and golds dominate, with the pinks in the flowers as an accent. The warmth of the colors and the overall color harmony hold the painting together.

Torre di Paola · *Oil on canvas* · *11" × 14" (28cm × 36cm)*

CREATE COLOR UNITY WITH PREMIXED GRAYS

Try mixing a cool gray, a warm gray, a light gray and a very dark gray on your palette. When you need a gray as a base or to tone down an intense color, your premixed grays will be ready to use. Using this small set of grays throughout the painting will help unify the color scheme to create overall harmony.

Choose a Format That Suits the Mood

When you compose a design, ask yourself what you want the painting to be about. Is it the sky, the land or a close-up of a subject? Think about what canvas size and proportion best suit that subject and the painting's mood.

- A small canvas is suitable for a delicate, intimate subject.
- A medium-size canvas with a standard horizontal shape creates a comfortable mood.
- Very large or long horizontal formats convey a majestic, dramatic or spacious mood.
- Vertical formats may come across as powerful and authoritative.
- Square formats give off a stark, angular, direct feeling.

When painting on location, take along a variety of canvas sizes so you can use the most appropriate one.

Beginners should consider starting out with smaller canvases, which promote simplification of compositions. Gradually use larger ones as you feel more confident about painting outdoors.

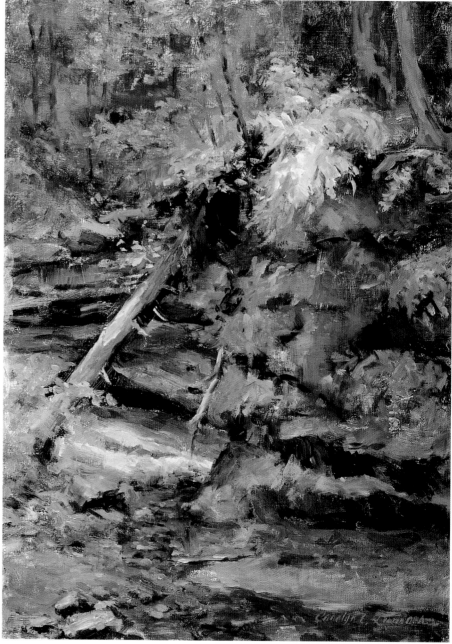

A Vertical Format Suits This Forest Scene
This woodland interior works well with a vertical format. The dead tree leaning against the rock walls may have gotten lost in a horizontal painting.

Path to Cedar Falls · *Oil on canvas panel* · *16" × 12" (41cm × 30cm)*

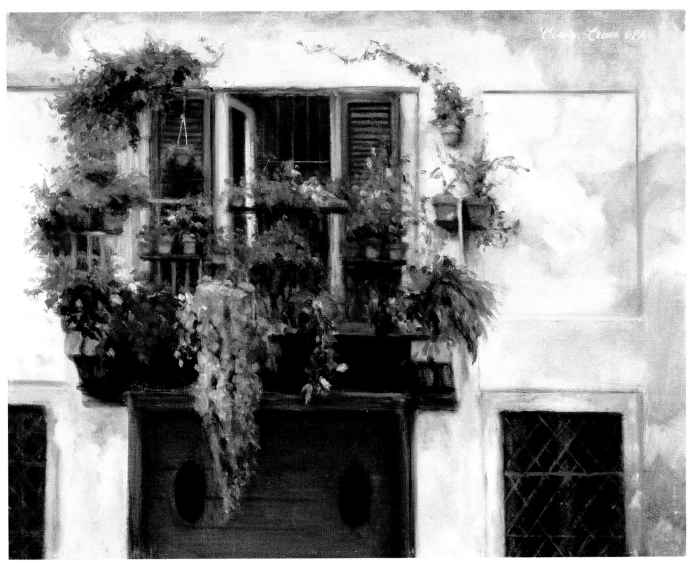

A Standard Shape Creates Just the Right Frame for This Subject

A standard format lent itself to this composition by cropping the windows and doors at crucial points. If the painting were more horizontal, too much wall would show and the focal point of the main balcony and window would not be framed well.

Flowers on the Balcony · *Oil on canvas* · *11" × 14" (28cm × 36cm)*

SUMMING UP: POINTERS FOR SUCCESSFUL COMPOSITIONS

Effective compositions usually have these qualities:

- **Three or four main values.**
- **A well-defined and well-placed focal point.** Use a compositional principle such as the tic-tac-toe principle on page 33. Generally this means your focal point will be somewhere between background and foreground, though there can be exceptions (see, for example, *Under State Street* on page 38).
- **Shapes with a directional quality** that move the eye toward the center of interest.
- **A unifying device,** which can be a color scheme, a single light source, or the use of linear patterns, to name a few.
- **Asymmetrical distribution of masses.** Avoid halves, such as half shade and half light, half warm and half cool, half land and half sky. Symmetrical distributions lack interest.
- **Simplification of shapes.** Use the artistic arrangement and combining of shapes to simplify a design.

Carolyn E Lewis OPA

CAPTURE LIGHT AND SHADOW

Light and shadow create form and thus give the illusion of reality to a painting. Choosing the correct values is essential to create convincing light and shadow. This chapter will show you how to render different lighting situations and different times of day. Being able to do this quickly is an important skill for plein air painters so that they can execute a study before the light changes. If only we could paint as fast as we can see!

Carmel Mission • Oil on canvas • 12" × 16" (30cm × 41cm) • Private collection

Understand the Nature of Light and Shadow

Understanding different light sources will help you assign convincing values in your painting. Doing a marker sketch on white paper or a charcoal sketch on pastel paper is a good way to develop this skill. If you have paper with a middle-value tone, simply add darks with very soft charcoal and use a white charcoal pencil for lighter values and highlights. Some artists like to start with a monochromatic painting, worrying not about color but about laying in the correct values. Then they can mix the right value of the right color to match the values they've already put down. Other artists lay in color right away, being careful to put down the right value of the local color in the correct shapes (as shown in steps 2 and 3 on page 17).

Capture the Light With Color and Value
The sky's drama is what caught my attention in this scene. The late-afternoon sun accented the pines and yellow aspen trees against the foreboding darkness of the clouds. The influence of the main light source gave a very warm glow on everything on the ground and even on the white cloud. I painted the lights with warm yellows and oranges and the shadows with blues and violets.

Lily Lake • *Oil on canvas* • *12" × 16" (30cm × 41cm)*

Study in Black and White
When doing a marker sketch, block in all shadow areas to distinguish the most obvious contrast between light and shadow. When doing the painting, don't lose the shadow areas that your black and white sketch reveals. Remember, the darkest light in your painting will not be as dark as the lightest shadow.

Overcast Days

On overcast days, the range of values is smaller than on a sunny day because there are no cast shadows. Painting on an overcast day—when the diffused, constant light creates a north-light atmosphere on your canvas, palette and subject—is easier than painting on a sunny day. The light on an overcast day is cooler compared to the warm light of a sunny day. You don't have to worry about the lights and shadows of an overcast day disappearing or rapidly changing, which gives you maximum painting time.

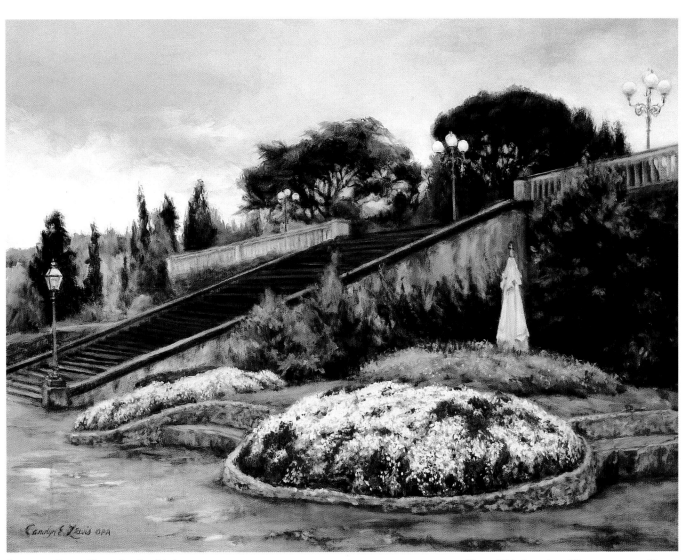

Overcast Days Have Cooler Light

The sky and puddles set the mood in this painting, but the flowers are the center of interest. When I encountered this scene, the rain had just ended and the richness of the colors shone through. Since there was no bright sun, the value contrast was created mostly by the colors of the objects themselves. The darks of the trees and shrubs bring out the off-white of the flowers in the foreground. The red flowers do not dominate the white ones but are a nice complement to the greens in the painting.

Piazza Michelangelo • Oil on canvas • 18" × 24" (46cm × 61cm)

Times of Day

Morning, midday, afternoon and evening each present challenges to the painter working outdoors. When seeking a spot to paint, consider the current light conditions *and* what the light will be like an hour or two from the time you start to paint.

Morning

Capturing early morning in a painting can be tricky because the sun is not high enough to shine directly on anything, which can make conditions resemble those of an overcast day. Morning light also changes very quickly, and one must be ready to deal with those changes. Morning fog is even more challenging.

If I want to capture the morning sun on a subject, I begin by laying in the basic shapes so that once the sun is up I'll already have the shadow areas, or at least the midtones, blocked in. I can then add lights and darks where I need them. If I don't want any bright sun on the subject, then I don't add that light. If the sun comes up as I am working, I memorize what I saw and try to depict that. Establish light and shadow patterns at the beginning of your painting; do not change your painting as the daylight changes. If you paint before sunrise in unfamiliar territory, carry a compass with you so you'll know where the sun will rise.

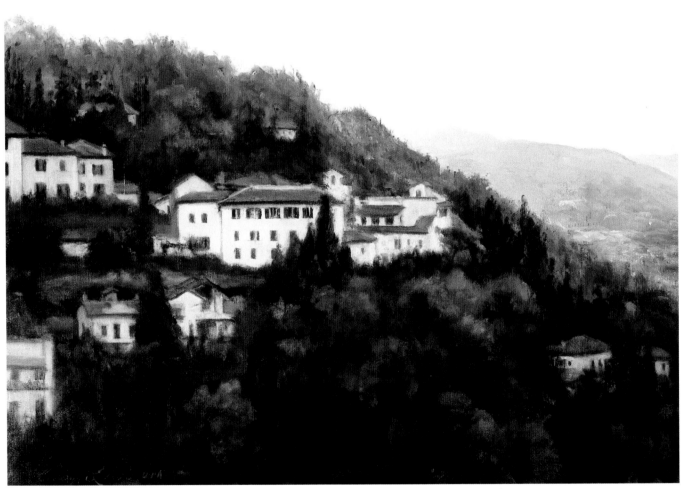

Morning Light Changes Quickly
While I painted this beautiful hillside in Italy, conditions changed from a downpour to a somewhat sunny day. The background haze gave the scene depth. I captured the light hitting the buildings on the hillside by using the correct values and temperatures as I saw them. The green of the trees made a good backdrop for the Naples Yellow homes and complemented the red roofs.

Fiesole • *Oil on canvas* • *12" × 16" (30cm × 41cm)* • *Private collection*

Midday

For me, midday is the least interesting time to paint because of the absence of long shadows. Midday is often a time of high contrast, though, which is a challenge to paint.

Facing the sun directly as you paint will yield high contrast between the glaring sunlight and the foreground shadows leading up to it. Your pupils will constrict when you look at the bright light, and they will dilate when you look back at your canvas. This makes judging values and colors difficult.

Painting with the sun behind you is easier on your eyes, but the sun may glare on your canvas or your palette and your shadow may fall across the canvas. Find a shady spot in which to paint, or use an umbrella to make your own shade.

Be Aware of Your Location When Painting Outside
This plein air study done at midday shows the sun just about directly above the glass roof on this greenhouse. I elected to put a shadow across the front part of the driveway to lead one's eye back to the the greenhouse.

New Harmony Greenhouse • *Oil on canvas panel* • *9" × 12" (23cm × 30cm)* • *Private collection*

Late Afternoon

I love doing paintings late in the after-
noon. In northeastern Ohio, where I live,
dramatic skies often occur during the heat
of late afternoons in summer. Whenever
you paint outside, expect the unexpected.
Be aware of the weather and the atmos-
pheric conditions and how they will affect
the quality of light as well as your mood.
Do your best to paint what you see.

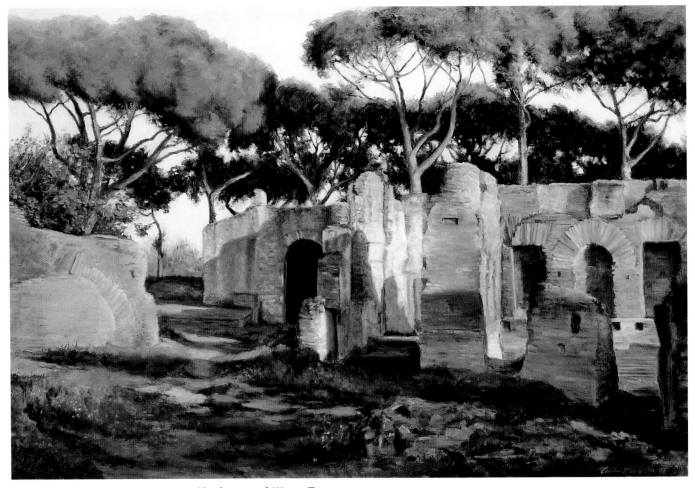

Late-Afternoon Sun Creates Long Shadows and Warm Tones
A late-afternoon painting may have a lot of sunlight. In this one, the sunlight provides
long shadows and a beautiful warm glow hitting the trees and ruins.

Palatine Hill · *Oil on canvas* · *24" × 36" (61cm × 91cm)*

Evening Light and Sunsets

Sunsets (along with sunrises) are the hardest times of day to paint on location because of the short time to work before the light is gone. If the sky is the subject, whether it be a sunset or beautiful cloud formations, paint the sky first and then key the land values to those of the sky. If the land is the focal point, paint it first and key the sky to the land. This will ensure harmonious values and color temperatures.

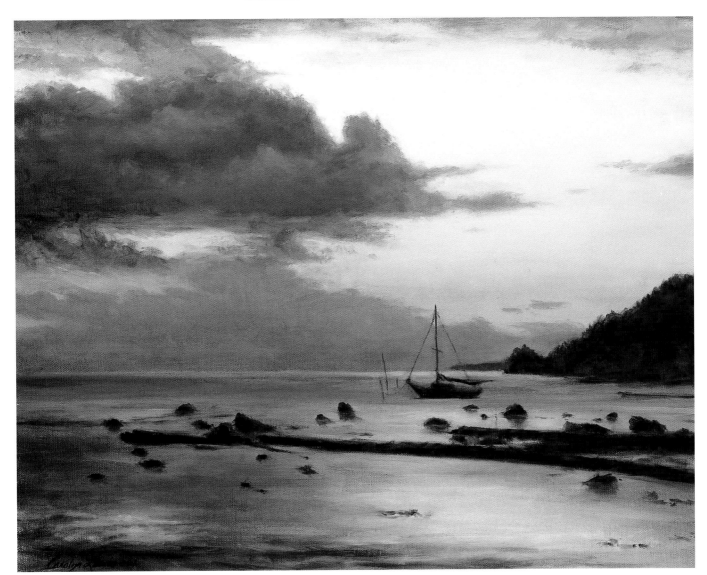

When Light Is Fleeting, Paint Key Elements First

This painting of an evening scene in Hawaii conveys a peaceful mood. I felt it needed a vertical line across the horizon, so I added the sailboat.

Evening Solitude • *Oil on canvas* • *16" × 20" (41cm × 51cm)*

Late-Afternoon Sun

Reference Photo
The size of these rocks at Ash Cave in Logan, Ohio, was awe inspiring. What really drew me to them, though, was the beautiful warm glow of the late-afternoon light reflecting on them. I also wanted to capture the splash of bright sun filtering through the trees to the rocky, sandy floor.

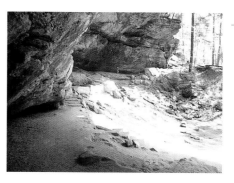

MATERIALS

PAINTS
Alizarin Crimson • Burnt Sienna • Burnt Umber • Cadmium Orange • Cadmium Yellow Medium • Cadmium Yellow Pale • Cobalt Blue • Cold Gray • Green Grey • Monochrome Tint Warm • Naples Yellow French • Neutral Grey • Permanent Red Medium • Rose Grey • Sap Green • Terra Rosa (or Light Red) • Titanium White • Ultramarine Blue • Warm Gray • Yellow Grey • Yellow Ochre

CANVAS
Stretched cotton canvas, acrylic toned, 12" × 24" (30cm × 61cm)

BRUSHES
No. 6 bristle flat • No. 18 sable bright • No. 18 mongoose filbert • No. 16 sable filbert • No. 12 badger bright • No. 10 sable cat's tongue

OTHER MATERIALS
Odorless mineral spirits • Winsor & Newton Liquin

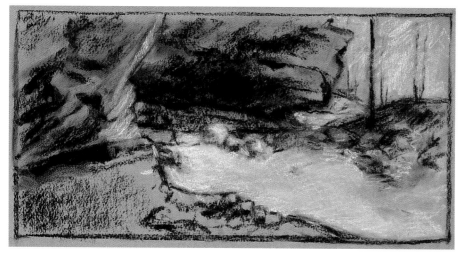

Value Sketch
I did this value sketch in charcoal on a middle-value Canson Mi-Teintes paper. I used soft charcoal for the darks and a white charcoal pencil for the lights.

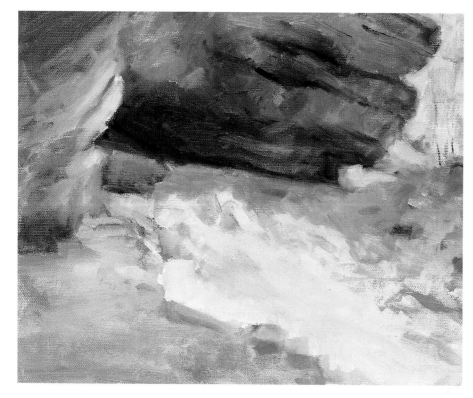

Study
In this study, I was just trying to capture the color notes I needed. Later, I elected to go with a longer canvas for the final painting.

USING TUBE GRAYS

You can modify a color with its complement or with a tube gray. Tube grays tend to be easier for the beginner to control. However, if you're using a limited palette, I recommend sticking with complements and using only a few tube grays if needed.

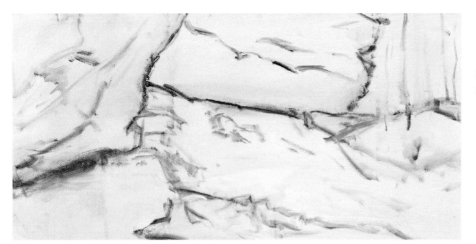

Sketch the Composition

1 Draw a sketch directly on toned canvas. Use a no. 6 flat and either an earth tone or Alizarin Crimson thinned slightly with odorless mineral spirits.

PURPLISH MIX, LEFT FOREGROUND
Alizarin Crimson + Ultramarine Blue + Neutral Grey

DARKEST DARKS
Burnt Umber + Sap Green

MEDIUM DARKS, ROCK ON LEFT
Cadmium Yellow Medium + Cadmium Orange + Alizarin Crimson Cold Grey

MEDIUM LIGHTS, ROCK ON LEFT
Cadmium Yellow Medium + Cadmium Orange + Alizarin Crimson + Warm Grey + Yellow Grey

MIDDLE DARKS, LARGE ROCK
Yellow Ochre + Cold Grey + Terra Rosa

MIDDLE LIGHTS IN FOREGROUND
Naples Yellow French + Cadmium Yellow Medium + Cadmium Orange

GREENISH GRAY AREAS ON ROCKS
Green Grey + Cold Grey + Neutral Grey + Yellow Ochre

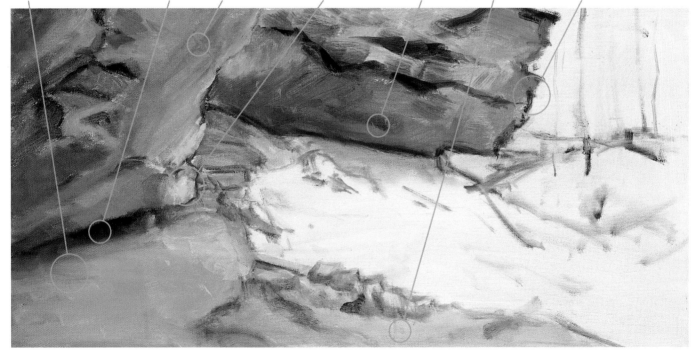

Block In

2 Scumble in the darkest areas (cracks, crevices and rock shadows) first, keeping the patterns simple. Paint the greenish gray areas on the large rock. Establish the form of the rocks through the direction of your strokes. Get as close as possible to the correct value and color.

Next put in the medium-darks and medium-lights on the left rock. If you lose your darkest darks by going over them, re-establish them.

For the shadow areas in the foreground, add some Alizarin Crimson, Ultramarine Blue and Neutral Grey to the medium-dark mixture you used in the left rock. This purplish color will be a little darker and cooler than the rest of the foreground. Put in middle lights in the foreground by blending these colors in gradually and extending them back toward the steps to the right of the big rock on the left.

This is only a base coat, so don't be concerned about details yet.

3 Add the Lights

Using the side of a no. 10 bristle flat, start applying the green of the trees, keeping the pattern simple. Then come back with the lighter color behind the trees. For the tree trunks, use a no. 10 sable cat's tongue or a filbert of similar size so you can easily taper the trunks as you go up. Next, using a flat or a bright, put in the darker shadow shapes created by the rocks below the trees, followed by the lighter shapes near the tops of the rocks. A flat will give the rocks a more chiseled look. Suggest dappled light and the path of light filtering through unseen trees onto the rocks. Try not to make the lights too busy. Finish laying in the lighter parts on the steps and foreground using a no. 16 sable filbert.

4 Develop the Rock on the Right

If the painting is dry, put a very thin layer of Winsor & Newton Liquin all over. Mix some of the colors you will be using. For the yellow areas on the rocks, start with the basic mixture listed at right. Then, to a portion of that mixture, add more Titanium White to make a lighter yellow for the brighter areas.

Working slowly from dark to light and in the direction of the rock shapes, create a textured effect in the rocks. Start by re-establishing the crevices if needed, then put in the darkest shapes, then the mid-value shapes and finally the lighter parts. Don't blend your colors too much; lay them in and leave them alone. This will create the appearance of more texture. If you lose the crevice details, paint them back in.

HIGHLIGHTS ON STEPS
Cadmium Yellow Medium + Titanium White

LIGHTER PARTS NEAR TOPS OF ROCKS
Cadmium Yellow Medium + Yellow Grey + Titanium White

SHADOW SHAPES BELOW THE TREES
Cold Gray + Sap Green + Burnt Sienna

DAPPLED LIGHT AND PATH OF LIGHT
Yellow Ochre + Titanium White + Cobalt Blue

BACKGROUND LIGHTS
Titanium White + Cadmium Yellow Pale + Cobalt Blue + Sap Green

TREE TRUNKS
Cold Gray + Rose Grey

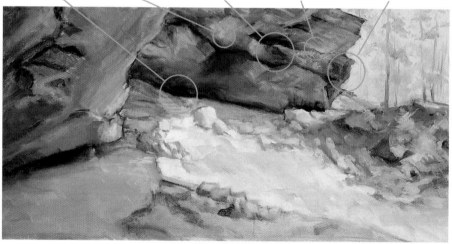

DARKER AREAS ON ROCKS
Warm Gray + Cadmium Yellow Medium + Ultramarine Blue

YELLOW AREAS ON ROCKS
Titanium White + Cadmium Yellow Medium + Warm Grey

CREVICES
Cadmium Yellow Medium + Burnt Umber + Alizarin Crimson + Ultramarine Blue

TEXTURED EFFECT ON ROCKS
Titanium White + Cadmium Yellow Medium + Permanent Red Medium + Cadmium Orange

GREEN-GRAY AREAS
Green Grey + Warm Grey + Neutral Grey

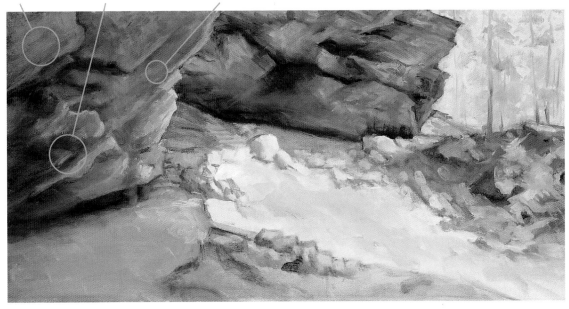

GREEN-GRAY AREAS
Monochrome Tint Warm

DARK AREAS
Warm Gray + Burnt Sienna +
Sap Green + Alizarin Crimson

MIDDLE TONES
Yellow Ochre + Cadmium
Orange + Terra Rosa

5 Develop the Rock on the Left

If the painting is dry, use Liquin as described at the beginning of Step 4. For the rock on the left, use a no. 12 badger bright or another soft-haired bright. Re-establish the darkest areas first. Next, put in green-gray areas. Then use slanted, varied strokes to apply the red-orange mixture to the yellow layers to bring out the chiseled edges of the rocks. Use more paint on your brush, and plan before you lay your strokes.

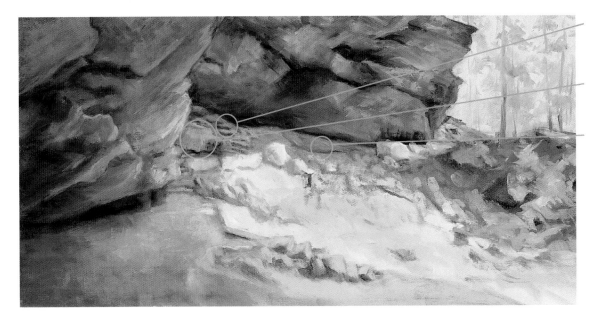

DARKER AREAS ON STEPS
Alizarin Crimson + Sap Green

GREEN-GRAY AREA
Monochrome Tint Warm

MIDDLE VALUES
Cadmium Yellow Medium +
Cadmium Orange

6 Refine Both Rocks

When adding paint to the rocks, drag your brush and do not use any medium. This will give you more of a dry-brush effect and keep the rocks from looking too soft. Start back into refining any darks, then build up to the lighter areas. Adding the gray-green areas makes the rocks more convincing and gives a little color variety.

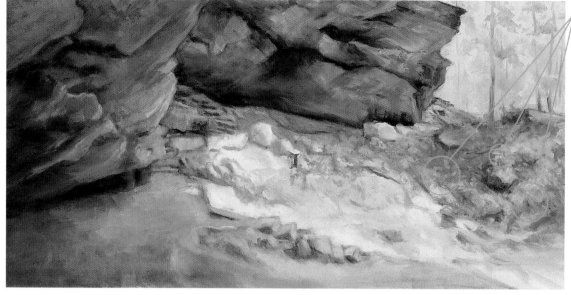

GREEN-GREY AREAS ON HILL
Yellow Ochre + Titanium White + Cobalt Blue

7 Rework the Hill on the Right

Bring out the previous stage even more, detailing the green areas on the hill on the right to suggest smaller leaf shapes. Use a smaller brush for small areas and larger ones for larger areas.

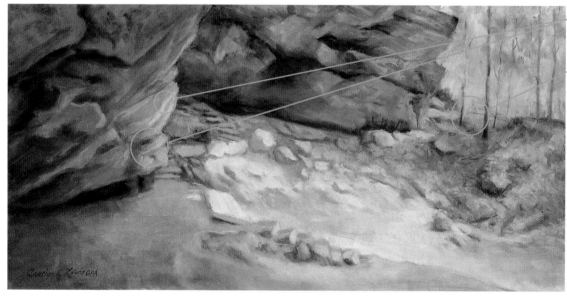

YELLOW ROCK ON LEFT
Cadmium Yellow Medium

CHANGED HILL SHAPE

8 Final Touches

Fix anything that doesn't look right. Small adjustments can make a big difference. At this stage, I noticed that the shape of the hill on the right made a V right where the trunk of the tree was, so I changed the shape of the top of the hill.

Next, I touched up the middle portion and rocks. Finally, I added Cadmium Yellow Medium to the rock on the left and in the background trees. What drew my attention to this cave in the first place was the size and most of all the wonderful warm glow that was happening underneath from all the reflected light. I felt it needed a touch more yellow to convey this mood.

> ### BRUSHES: BIGGER IS BETTER
>
> Use the largest brush that works. This reduces the temptation to overwork your painting with too many strokes.

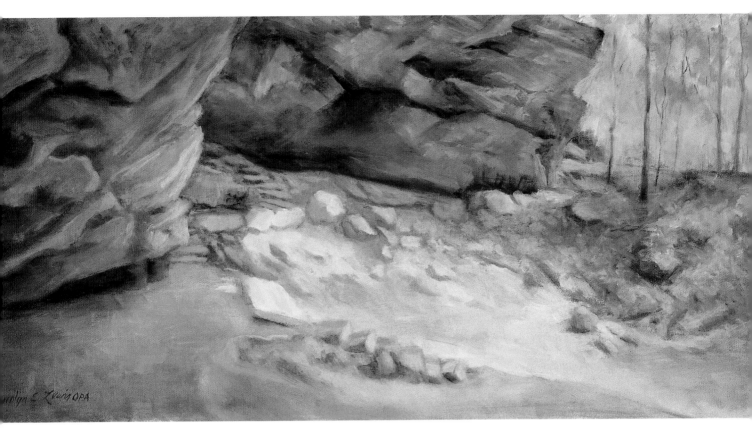

Ash Cave • *Oil on canvas* • *12" × 24"*
(30cm × 61cm)

Detail
This detail shows the edges of the rock against the trees in the background. Hard edges draw attention to an area of a painting; I elected to keep the edges of this rock softer since it is not the main focal point.

Early-Morning Sun

Photographers and artists play an important role in capturing history. This painting shows a lock from the old Ohio & Erie Canal, which opened in 1827 between Cleveland and Akron. The lock is in ruins yet is filled with wonderful wildlife. Bikers and hikers in the Cuyahoga Valley National Park use a trail that follows the abandoned canal.

Reference Photo

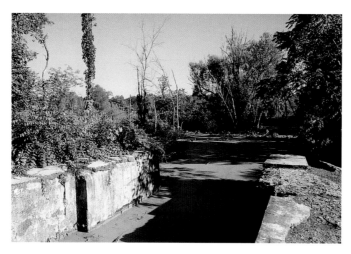

MATERIALS

PAINTS
Alizarin Crimson • Burnt Sienna • Burnt Umber • Cadmium Yellow Lemon • Cadmium Yellow Medium • Cadmium Orange • Cobalt Blue • Cold Gray • Green Grey • Naples Yellow • Neutral Grey • Permanent Red Medium • Sap Green • Titanium White • Phthalo Blue • Ultramarine Blue • Warm Gray • Yellow Ochre

SURFACE
Stretched cotton canvas, acrylic toned, 12" × 16" (30cm × 41cm)

BRUSHES
Nos. 6 and 10 bristle flat • Nos. 6 and 10 sable cat's tongue • No. 12 badger bright • Nos. 6, 10 and 18 mongoose bright • No. 6 bristle filbert

OTHER MATERIALS
Winsor & Newton Liquin

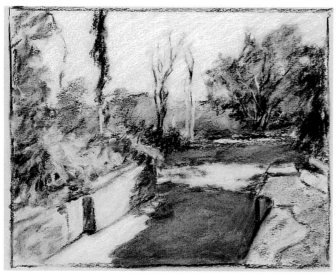

Value Sketch
This value sketch was done in charcoal on a middle-value Canson Mi-Teintes paper. Soft charcoal was used for the darks, and a white charcoal pencil was used for the lights.

1 Sketch in the Composition
Sketch the composition with a no. 6 bristle filbert and an earth tone color such as Yellow Ochre, Burnt Sienna or Burnt Umber.

SKY
Titanium White + bit of Phthalo Blue + bit of Cadmium Yellow
Lemon grayed down with Neutral Grey

REDDISH BROWN OF TREE ON LEFT
RED: Alizarin Crimson + Permanent Red Medium + Sap Green
BROWN: Red mixture + Cadmium Orange

LIGHTER PARTS AT TOPS OF TREES
Cadmium Yellow Medium + Sap Green + Titanium White + a little
Permanent Red Medium

TREES AT LEFT
Cadmium Yellow Medium + Sap Green

WARM AREAS OF BACKGROUND TREES
Background mixture + Cadmium Yellow Medium

BACKGROUND HILLS AND TREES
Cadmium Lemon + Ultramarine Blue toned down with a little
Permanent Red Medium

BUSHES IN FRONT OF HILLS
Reddish brown mixture + Titanium White + Yellow Ochre

2 Lay In the Top Half of the Painting

Lay in the sky with a no. 10 bristle flat. Begin by dipping the dry brush in mineral spirits and wipe off any excess. Then use some medium with the color mixture if necessary for smooth application. Work your way down to the horizon and lighten the sky color with an added touch of Alizarin Crimson for a pinkish look.

Next, lay in the hills and distant trees in the background. Working from the back (top) forward (down), use the same brush and blend up into the sky for a softer edge. Then put in the background tree on the right, adding warm areas of sunlight to it. To the trees behind that, some Cold Gray can be added to take them back visually and give more depth to the painting.

Put in the lighter parts of the trees near their tops, where the sun hits and the sky reflects on them. With a no. 6 bristle flat, carefully soften the edges near the top into the sky. For the shadow parts of the tree, add some Cobalt Blue to what you just used. Once this is done add the trees on the left side by brushing them on loosely, using the side of your brush.

Finally, with the same brush, put in the reddish brown tree on the left followed by the bushes in front of the distant hills on the left.

DARKER FOLIAGE ON TOP OF WALL
Cadmium Yellow Medium + Sap Green

LOCK WALL (BASE COLOR)
Warm Grey + Titanium White

FLOWERS
Cadmium Yellow Medium

LIGHTER FOLIAGE ON TOP OF WALL
Cadmium Yellow Medium + Sap Green + Titanium White

LOCK WALL (WARM GRAYS)
Warm Gray + Titanium White + Yellow Ochre

LOCK WALL (COOL GRAYS)
Titanium White + Cold Grey + Alizarin Crimson

3 Lay In the Bottom Half of the Painting

For the shadows on the duckweed, use a no. 18 mongoose bright, working from dark areas to light ones. Use a no. 6 sable cat's tongue to paint the dappled light peeking through the duckweed shadow.

Next, put in the warm and cool areas of the lock wall, laying in the different grays without blending them (try to put the paint down and leave it alone). Once the paint is almost dry, you can use a drybrush technique. Try to make the lock look rough-textured.

Next, with a no. 6 bristle filbert, lay in foliage on top of the left wall, working from dark to light. Add the tree on the right above the wall. Suggest yellow flowers in the foliage on the left.

LIGHT ON DUCKWEED
Titanium White + Cadmium Yellow Lemon + Sap Green + a little Neutral Grey

SHADOWS ON DUCKWEED
Cadmium Yellow Lemon + Ultramarine Blue + Green Grey + Cold Gray

4 Touch Up the Sky, Distant Hill and Trees

For the second stage of the sky, use a no. 18 mongoose bright to go over parts that need improving. Then, with the same colors you used before, use no. 10 and no. 6 mongoose brights to go over the distant tree on the right, the distant hill and the tree with reddish leaves. You can also apply some of the yellowish green used on the lighter part of the duckweed in certain areas where you see fit.

Suggest branches on the background tree at right using a no. 6 sable cat's tongue and a mixture of Burnt Umber, Yellow Ochre and Naples Yellow.

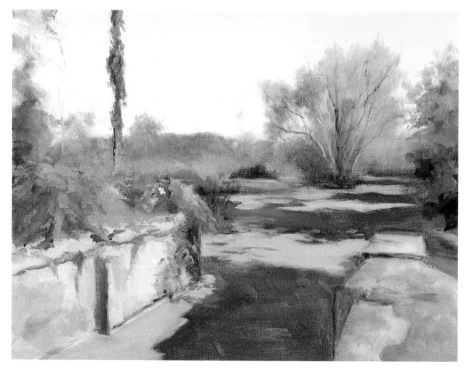

DEAD TREES AND BRANCHES
Yellow Ochre

DEAD TREES AND BRANCHES
Burnt Sienna

5 **Add Details to Duckweed**
Using a no. 12 badger bright and a no. 6 mongoose bright, go over duckweed using the same colors as in Steps 3 and 4. Put in more detail for branches and dead trees in the marsh. Add more dappled light if needed in the shadow areas of the duckweed.

GREENERY (WARM GREENS)
Titanium White + Cadmium Yellow Medium + Sap Green + Cobalt Blue

GREENERY (COOL GREENS)
Cadmium Yellow Lemon + Cobalt Blue

ADD TO LOCK MIXTURE IN CERTAIN PLACES
Titanium White + Yellow Ochre

LOCK WALLS
Titanium White + Cadmium Yellow Medium + Alizarin Crimson

6 **Second Stage of Lock Wall and Greenery on Top of Left Wall**
Add more color and detail to the lock wall and bring out the greenery on the left side and the top of the wall using no. 6 mongoose bright and a no. 10 sable cat's tongue.

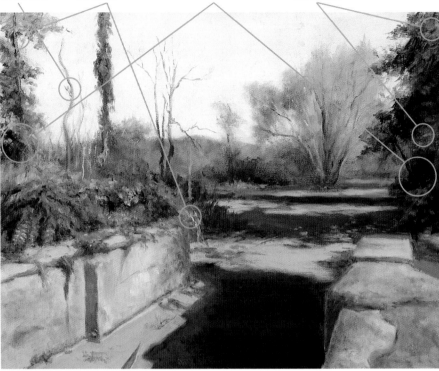

7 Correct the Tree and Add Smaller Details

At this stage I moved the curved tree in the background to correct the spacing between trees, which was too even.

Put in the sunlit areas on the tree trunks and leaves. If needed, use for tinier places a small brush like a no. 6 sable round. Add detail to the thicker and fuller trees on the right by adding dark value areas and light value areas. Be sure to keep your strokes loose and vary the edges on the left side of the trees.

Put in little dead background trees with a no. 6 mongoose bright or a no. 6 sable round, using warm colors such as a mixture of Titanium White and Yellow Ochre.

MOVED TREE

SUNLIT AREAS ON TREE TRUNKS AND LEAVES
Titanium White + Cadmium Yellow Medium + Permanent Red Medium

FULL TREES (DARK-VALUE AREAS)
Sap Green + purples made of Titanium White + Cobalt Blue + Permanent Rose

FULL TREES (LIGHT-VALUE AREAS)
Cadmium Yellow Medium + Titanium White

8 Final Touch-Ups

Do any final touch-ups. I touched up the trees in the background with a no. 6 sable round, making them brighter, and went over branches using a no. 6 mongoose bright to paint light hitting the tops of the trees. Add light to the tree trunks. Go over the left tree and the reddish tree and add some more leaves. Finally, lighten the wall and the foliage and touch up the sky.

LIGHT ON TREE TRUNKS
Cadmium Orange + Burnt Sienna

LIGHT ON WALL AND FOLIAGE
Cadmium Yellow Medium + Titanium White

LIGHT ON TREETOPS
Cadmium Yellow Lemon + Cadmium Yellow Medium + Titanium White

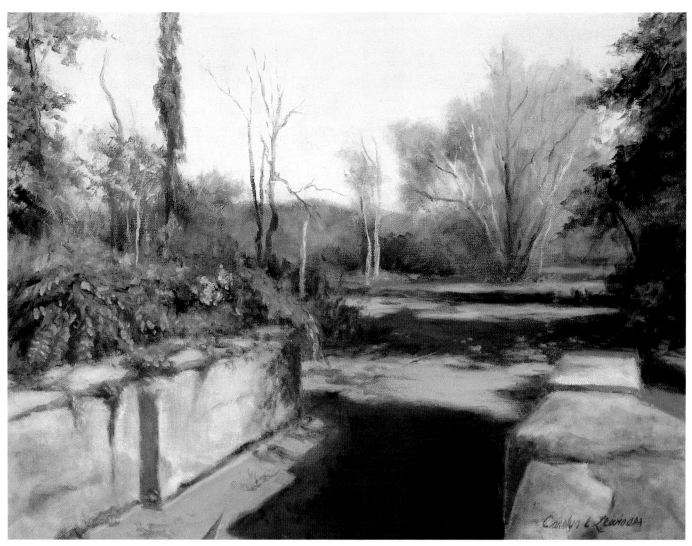

Finished Painting

In the summer the duckweed is very visible here with its bright yellow-green color. I wanted to capture the early-morning tree shadows crossing the old canal.

Lock 26, Pancake Lock · *Oil on canvas* · *12" × 16" (30cm × 41cm)*

Detail

This close-up of the lock wall and duck-weed shows the dappled-light effect and the coral canvas coming through.

Shadows and Backlighting

Pacific Grove, on the California coast, is known for its many well-preserved Victorian homes as well as its thriving population of monarch butterflies. On this particular beach, Lover's Point lends its beauty to the surrounding seascape. The view in spring, when the bright pink ice plant is in bloom, is one you won't forget.

Reference Photo

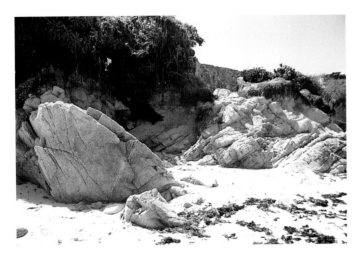

MATERIALS

PAINTS
Alizarin Crimson • Burnt Sienna • Cadmium Orange • Cadmium Yellow • Cadmium Yellow Lemon • Cobalt Blue • Cold Gray • Green Grey • Naples Yellow • Neutral Grey • Permanent Red Medium • Permanent Rose • Phthalo Blue • Rose Grey • Sap Green • Terra Rosa • Titanium White • Ultramarine Blue • Warm Gray • Yellow Grey • Yellow Ochre

SURFACE
Stretched cotton canvas, acrylic toned, 16" × 20" (41cm × 51cm)

BRUSHES
No. 18 sable bright • Nos. 4 and 10 sable cat's tongue • No. 10 bristle flat • No. 6 bristle filbert • Nos. 6, 10 and 18 mongoose bright • Nos. 7 and 12 sable filbert

OTHER MATERIALS
Winsor & Newton Liquin

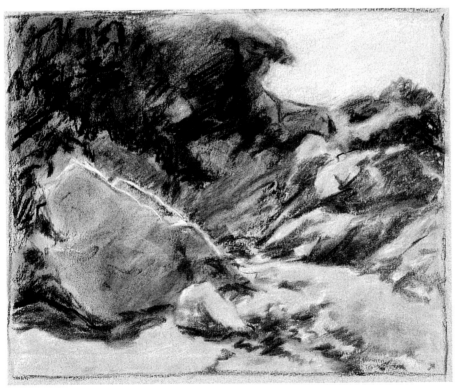

Value Sketch
This value sketch was done in charcoal on a middle-value Canson Mi-Teintes paper. Soft charcoal was used for the darks, and a white charcoal pencil was used for the lights.

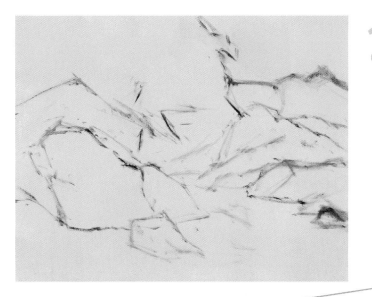

Sketch the Composition
On a toned canvas, draw a sketch using a no. 6 bristle filbert.

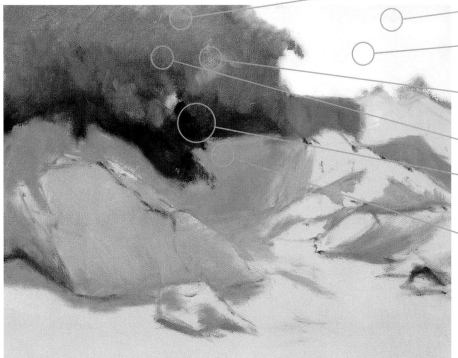

SUNLIT AREAS OF LARGE BUSHES
Cadmium Yellow Lemon + Titanium White + Cobalt Blue

TOP OF SKY
Sky mixture + Phthalo Blue (+ Neutral Grey where needed)

SKY
Titanium White + Phthalo Blue + Cadmium Yellow Lemon + Liquin, if necessary

LIGHTER BROWN AREAS
Titanium White + Yellow Ochre + Permanent Red Medium + Neutral Grey

LARGE GREEN BUSHES
Green Grey + Ultramarine Blue + Sap Green

DARK AREAS UNDER GREEN BUSHES
COOL: Titanium White + Alizarin Crimson + Ultramarine Blue + Cold Grey + Neutral Grey to lighten
WARM: Burnt Sienna + Warm Grey

AREAS UNDER BUSHES ON THE ROCKS
Terra Rosa + Cold Grey + Neutral Grey (to lighten)

Lay In Background and Shadows
Start blocking in the sky using random strokes with a no. 10 bristle flat. Lighten the sky as you work down toward the horizon by adding more Titanium White to the sky mixture. Add dark areas underneath the green bushes. Use the two different mixtures of warm and cool colors for the area under the bushes on the rocks. Neutral Grey can be added to make a lighter color. Put in the larger green bushes, and be sure to lighten areas where the sun hits.

LIGHT AREAS ON ROCKS AND SAND
Titanium White + Yellow Ochre + Cadmium Yellow

DARKS OF SEAWEED
Burnt Sienna + Sap Green + Yellow Ochre + Rose Grey

SUNNIER PARTS OF FLOWERS
Dark mixture + Cadmium Yellow

PINK FLOWERS AT RIGHT
Permanent Rose + Titanium White + Cadmium Yellow, if too pink

FLOWER DETAIL
Permanent Red Medium

DARK AREAS UNDER FLOWERS
Cadmium Yellow + Sap Green + Permanent Red Medium + Ultramarine Blue

LIGHT AREAS OF SEAWEED
Sap Green + Yellow Ochre + Rose Grey

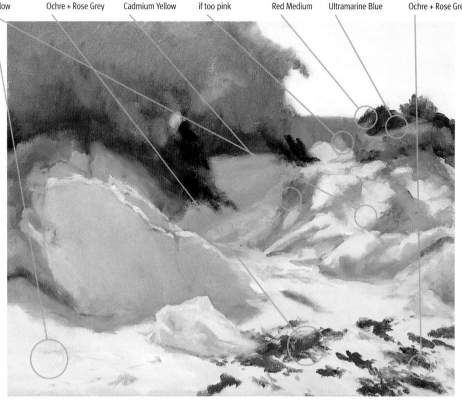

3 Lay In the Bottom Half of the Painting

Put in the last half of the painting with a no. 10 mongoose bright. Start at the top and lay in the darks under the flowers. If the paint drags too much on the canvas, use a little Liquin. Next, put in the sunnier parts and suggest the flowers.

Use a smaller brush, like a no. 6 mongoose bright, for the pinker flowers to the right. Then reshape the rocks and paint the sand with a warmer glow, redrawing the cooler shadows if needed. Using a no. 18 mongoose bright and as few strokes as possible, chisel the rock to give it direction. Then apply dark and light areas of seaweed. Next go back and fill in shadow parts on rocks.

CORAL AREAS ON WALL
Titanium White + Cadmium Yellow + Permanent Red Medium

WALL UNDERNEATH BUSH
Yellow Ochre + Warm Gray + Terra Rosa for modification OR Naples Yellow to lighten

COLORATION FOR STONE WALL TO RIGHT OF BUSH
Yellow Grey + Terra Rosa OR Naples Yellow + Titanium White

STONE WALL
Yellow Grey + Permanent Red Medium + Cobalt Blue

COOL GREY
Titanium White + Permanent Rose + Cobalt Blue

SKY
Titanium White + Cadmium Yellow + Phthalo Blue

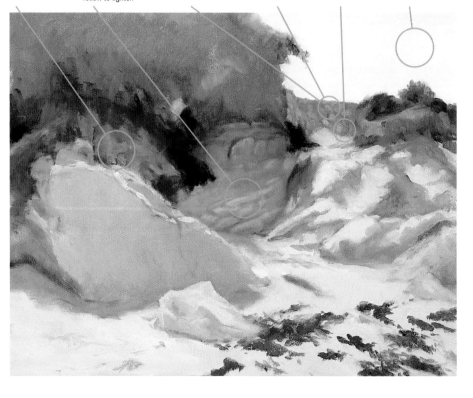

4 Paint the Second Stage

If the canvas is dry, go over everything with a light coat of Liquin using a no. 10 bristle flat. This will bring out the color, make for an easier second application and hasten the drying time.

Rework the sky. For the gradation to the sky use a softer brush, like a no. 18 mongoose bright and random strokes. Where needed, add some lighter pinks and yellows to vary color and value. Then, using a no. 10 sable cat's tongue, work on the stone wall to the right of the bush. Lay in colors without mixing one into the others. Try to keep it simple—just suggest variety. Then add color variety to the wall underneath the bush. Finally, with the no. 18 mongoose bright, lay in cooler areas. Again, try to keep your strokes to a minimum.

PURPLES UNDER BUSH (WARM AREAS)
Rose Grey + Warm Gray + Burnt Sienna

SHADOW UNDER ROCK
Titanium White + Ultramarine Blue + a little Burnt Sienna

LEAVES NEAR TIPS
Terra Rosa + Cadmium Yellow + tad of Green Grey

SUNLIT AREA ON TOP
Titanium White + Cadmium Yellow Lemon + a little Cobalt Blue

PURPLES UNDER BUSH (COOL)
Permanent Rose + Cobalt Blue + Cold Gray

DARKER AREAS OF BUSH
Alizarin Crimson + Slate Blue

GREENS OF BUSHES
Cadmium Yellow Lemon + Cobalt Blue + Cold Gray

FLOWERS (RED)
Permanent Red Medium

DARK GREENS
Cobalt Blue + Cadmium Yellow Lemon

FLOWERS (PINKISH PURPLE)
Titanium White + Permanent Rose + Cadmium Yellow

GREENERY AND FLOWERS AT RIGHT (WARM)
Cadmium Yellow Lemon + Cadmium Yellow + a little Sap Green

ROCKS IN WALL, CENTER
Titanium White + Neutral Grey + Ultramarine Blue + Permanent Rose + Naples Yellow OR Yellow Grey

CORAL COLOR
Cadmium Yellow Medium + Permanent Red Medium + Titanium White + Naples Yellow grayed down with Neutral Grey

5 Paint the Third Stage

Re-establish rocks in the wall using a no. 10 sable cat's tongue. Re-establish darks at the top of the bush with a no. 12 sable filbert, then add some purples underneath the bush. To suggest the spider-shaped green leaves, use the side of your brush and angle it. Add deep brown or purple to the bush in the darker areas with Alizarin Crimson and Ultramarine Blue. Then, put in the sky hole with a blue a little darker than the sky's. Tone down the warmer parts of the leaves near the tips.

Suggest the lighter areas of the bush just beneath the sunlit part to the right of center using a no. 4 sable cat's tongue. Use the grayish purple color to suggest vines. Next, give more texture to the bush where it connects down into the rocks; using colors left over on your palette, or what I call soup (see page 22). With a no. 7 sable filbert, put in the sunlit area on the top of the bush. For the greenery and flowers to the right, use a no. 4 sable cat's tongue. Add the warm greens and the dark greens. Next put in the red and pinkish purple flowers. Using the same brush, put in the green and the flowers to the left of the large rock. Start with Green Grey for the cooler green and some purple mixture for the bottom side of the greenery. Finally put in the shadow area coming out of the rock.

BEACH
Titanium White + Naples
Yellow + Cadmium Yellow +
Permanent Red Medium

SEAWEED
Permanent Red Medium + Burnt
Sienna + a little Cadmium
Orange + Neutral Grey

6 Refine Foreground Elements

Add some finer details to identify the large rock on the left and make it look more realistic. Use a no. 6 mongoose bright for smaller areas and a no. 18 mongoose bright for larger areas. Mix the same purples as before, and mix a reddish brown with Terra Rosa and a little Burnt Sienna.

Put in the beach mixture with a no. 18 red sable bright. Then put in the seaweed. Darken some areas of seaweed with a mixture of Sap Green and a little Alizarin Crimson.

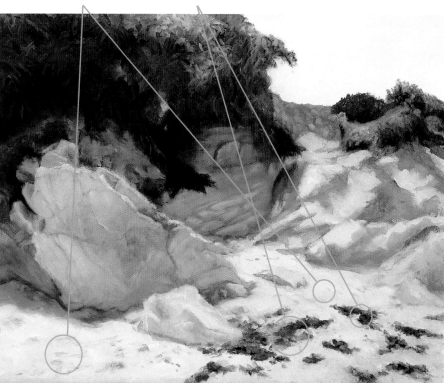

7 Go Over Rocks on the Right

Make any final improvements using the same brushes and colors as before.

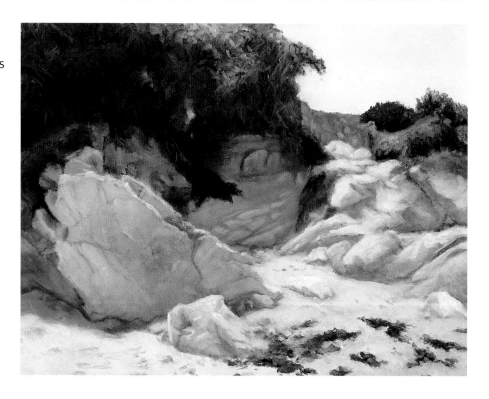

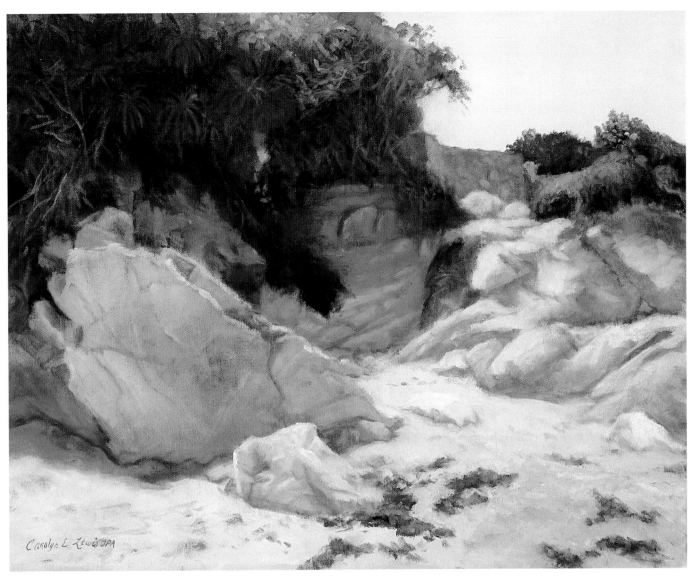

Pacific Grove Beach • *Oil on canvas* • *16" × 20" (41cm × 51cm)*

Detail
Notice how the backlit highlight on the edge of the large rock sets it off just enough from the background behind it.

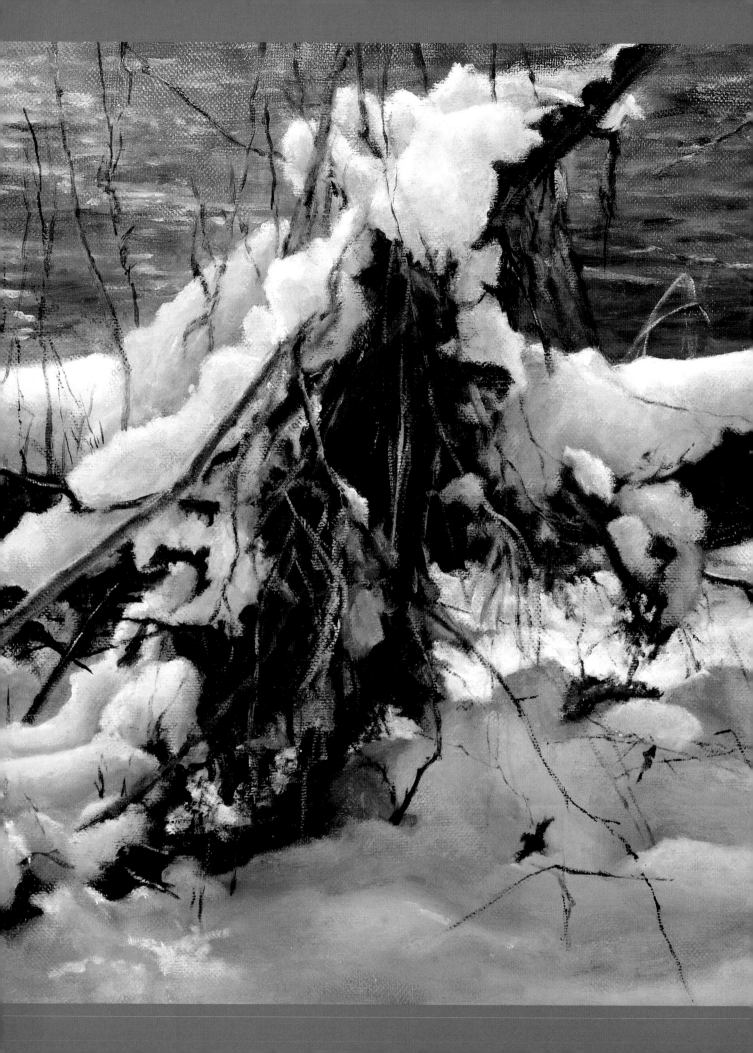

CHANGE WITH THE WEATHER

The plein air painter has to deal not only with changing light conditions but also changing weather. Painting a storm can result in a dramatic work full of energy and excitement. An artist attempts to convey the feeling of a painting's subject for a particular moment in time. A wintry snowfall painting can make the viewer feel cold, where a desert painting can have the opposite effect. Painting out in the elements helps artists make their work more convincing because they feel what they want the viewer to feel. However, that doesn't mean skipping precautionary measures such as the right clothing gear and common sense. For instance, it wouldn't be a great idea to stand out in a field during an electrical storm!

Winter Magic • *Oil on canvas* • *15" × 21" (38cm × 53cm)* • *Private collection*

Painting on Overcast Days

Overcast days are the easiest times to paint outdoors, as the light is fairly constant. The lack of contrast can make for a flat painting, so, on days like this, I like to find a subject that has some inherent contrast of color or value.

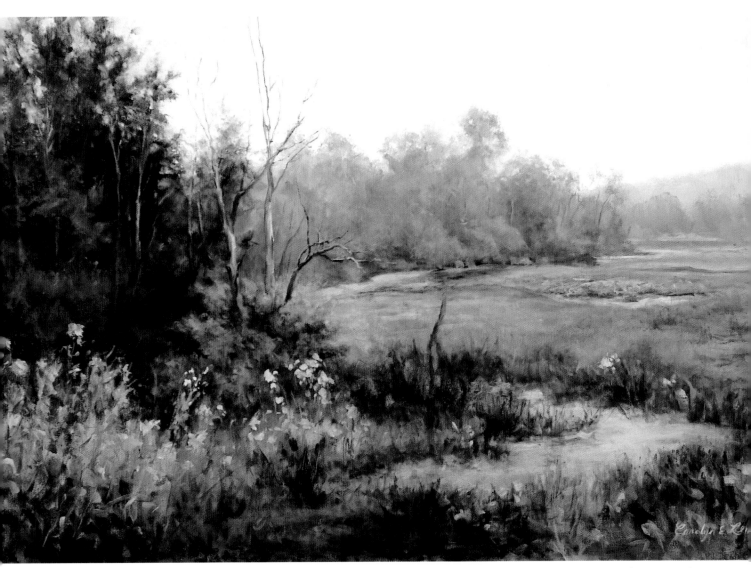

On an Overcast Day, Look for Contrast in Subject Matter
The contrast between the foreground trees and the background trees adds depth and interest to this scene.

Cuyahoga Valley Marsh • *Oil on canvas* • *20" × 30" (51cm × 76cm)*

Using Contrast on an Overcast Day

When there is no direct sun to create contrasts of light and shadow, look for subjects with some inherent value contrast. Whether or not it's overcast, it's always good to distribute light and dark values unequally for a more interesting composition.

MATERIALS

PAINTS
Burnt Sienna • Burnt Umber • Cadmium Red Light • Cadmium Yellow Lemon • Cadmium Yellow Medium • Cerulean Blue • Coral Red • Green Grey • Naples Yellow • Sap Green • Titanium White • Ultramarine Blue • Yellow Ochre

CANVAS
Stretched canvas or canvas board

BRUSHES
No. 18 mongoose filbert • no. 10 sable cat's tongue

DARK PART OF TREES AND BUSH
Cadmium Yellow Medium + Ultramarine Blue + Cadmium Red Light

MIDDLE VALUES OF BUSH
Cadmium Yellow Medium + Sap Green

LIGHTER VALUES OF DARK GREEN TREES ON LEFT
Titanium White + Cadmium Yellow Lemon + Ultramarine Blue

SKY
Titanium White + Cadmium Yellow Medium + Cerulean Blue

DISTANT TREES ON RIGHT
Titanium White + Cadmium Yellow Lemon + Ultramarine Blue

DISTANT ORANGE BUSHES
Coral Red + Burnt Sienna

MARSH
Titanium White + Cadmium Yellow Lemon + Green Grey

LIGHTER VALUES OF BUSH
Titanium White + Cadmium Yellow Lemon + Sap Green

FOREGROUND
Yellow Ochre + Cadmium Yellow Medium + Cadmium Red Light

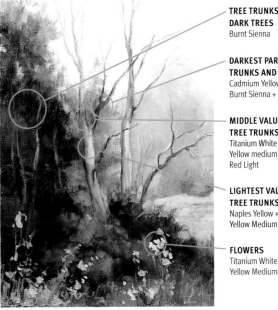

TREE TRUNKS IN DARK TREES
Burnt Sienna

DARKEST PARTS OF TRUNKS AND BRANCHES
Cadmium Yellow Medium + Burnt Sienna + Burnt Umber

MIDDLE VALUES OF TREE TRUNKS
Titanium White + Cadmium Yellow medium + Cadmium Red Light

LIGHTEST VALUES OF TREE TRUNKS
Naples Yellow + Cadmium Yellow Medium

FLOWERS
Titanium White + Cadmium Yellow Medium

1 Lay In Basic Shapes
Use a no. 18 mongoose filbert to lay in the sky with random strokes on a toned canvas board. Next, put in distant trees, keeping their edges soft. Add the darker background tree at the left. (If the sky color gets on your brush, wipe it off so you won't alter the green mixture—or wait till the sky dries before continuing with the trees.) Lay in the marsh using grayed-down colors to help it look distant. Add the bush under the bare trees next, starting with the darkest darks and moving to the lightest colors. Add the warm foreground colors last.

2 Add Trees and Flowers
Correct any values or colors that need correcting, then lay in foreground trees. Then, using the side of a no. 10 sable cat's tongue and lifting your arm as you go, lay in the the barren trees with loose, flowing strokes. Start with the darkest darks and move to the lighter colors. Suggest the tree trunks in the pines, making them more subdued than the main barren trees. Dab in the flowers last.

Stormy Scenes

Weather conditions can strongly influence the appearance of a painting. Atmospheric conditions can change the values and colors of a landscape quite drastically. For instance, when it's raining or snowing, edges appear softer, an effect that increases the further in the background they are.

Painting reflections accurately will make your wet-weather paintings more convincing. It's important to get the reflections' edges and values correct. In standing water, the hues in a reflection usually are muted compared to those of the object being reflected. If the water is moving at all, the reflection will be distorted.

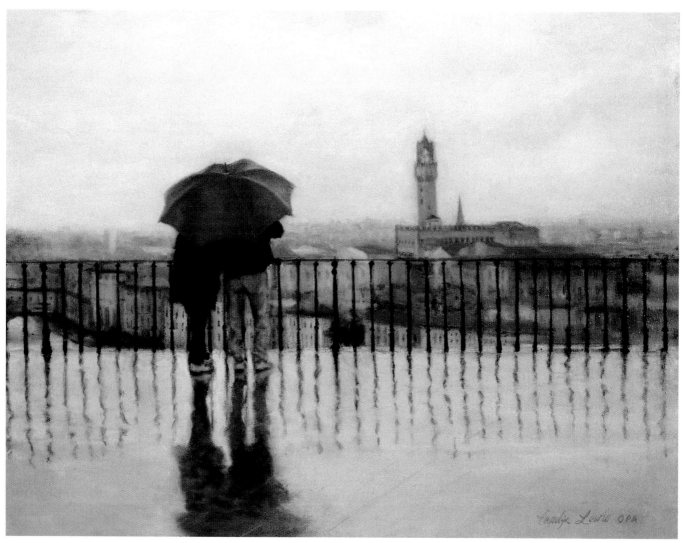

Venture Out in the Rain
Even a rainy day can make a good painting subject. The colors can be very rich, and the reflections add interest to a scene.

The Red Umbrella • *Oil on canvas* • *12" × 16" (30cm × 41cm)* • *Private collection*

BE PREPARED

Dress for any possible weather when painting outdoors. Wear a windproof top layer that doesn't restrict your movement. I always carry a parka with a hood, just in case. Even on a mild day, one can get cold after standing outside for three or four hours.

Paint a Reflection

Reflections usually appear less intense in hue than the actual objects being reflected. A deep black becomes a dark gray; bright white reflects a shade darker. Colors are grayed somewhat, and edges generally are softer.

COATS
Burnt Sienna + Naples Yellow + Ultramarine Blue

PANTS
Cerulean Blue + Ultramarine Blue + Cadmium Red Light + Cadmium Yellow Medium

WROUGHT IRON
Burnt Sienna

UMBRELLA
Cadmium Red Light + Cadmium Yellow Medium + Burnt Sienna

MATERIALS

PAINTS
Burnt Sienna • Cadmium Red Light • Cadmium Yellow Medium • Cerulean Blue • Naples Yellow • Titanium White • Ultramarine Blue

CANVAS
Stretched canvas or canvas board

BRUSHES
No. 12 badger bright • no. 18 mongoose bright • no. 20 mongoose filbert

1 Lay In Darks
Use a no. 12 badger bright to put on a toned canvas the darks for the jacket, jeans, umbrella and wrought iron. Make the edges soft so it comes across as a reflection. Keep the wrought iron crooked, making the lines "skip" in some places to indicate the unevenness of the pavement on which the water has puddled.

2 Add Lights and Drag to Soften
Using a no. 18 mongoose bright, add lighter color between the wrought iron and around figures. Then, with a larger no. 20 mongoose filbert, drag the brush back and forth across the image, more in some places than others. Drag some of the darks into the lights and vice versa. This gives the impression that the pavement surface breaks up the reflection. If the pavement surface weren't suggested, the figures would look as if they were walking on water.

SPACES BETWEEN WROUGHT IRON
Titanium White + Cadmium Yellow Medium

CONCRETE
Titanium White + Cadmium Yellow Medium + Cadmium Red Light + Cerulean Blue

Misty or Foggy Conditions

Fog and haze can almost totally obscure the background of a scene depending on how far away it is. Mist is common on cool autumn mornings, especially over water. All these weather conditions tend to flatten the tonal range of a scene. When subtle color and value differences are obscured, shapes appear simplified.

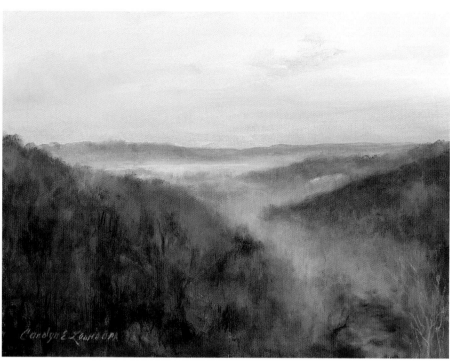

Mist and Fog Limits the Tonal Range of the Background
Looking down from a bridge on a cool fall morning as the sun came up behind me I found this beautiful scene. Notice that the farther you go into the background, the more compressed the value range becomes.

Misty River Sunrise · Oil on canvas · 12" × 16" (30cm × 41cm)

Painting Foggy Weather
The heavy fog almost obscures this scene and creates an eerie, haunted feeling.

Abandoned Paper Mill · Oil on canvas · 9" × 12" (23cm × 30cm)

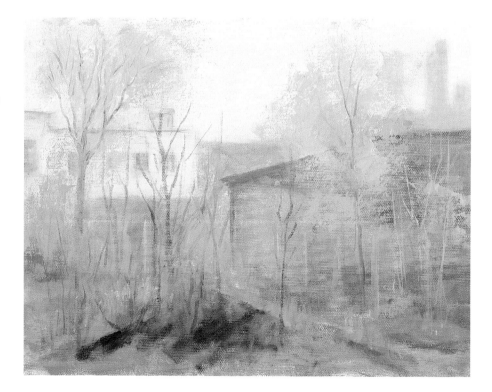

Paint a Tree in Fog

Fog will change values from how they would appear on a sunny day. The overall value range is compressed, color is grayer amd less intense and edges are usually softer. Detail will also be reduced on objects such as trees.

MATERIALS

PAINTS
Cadmium Yellow Medium • Cerulean Blue • Green Grey • Titanium White • Warm Gray

CANVAS
Stretched canvas or canvas board

BRUSHES
No. 20 mongoose filbert • no. 6 sable cat's tongue

OTHER MATERIALS
Trowel palette knife

SKY
Titanium White + Cadmium Yellow Medium + Cerulean Blue

FOLIAGE
Titanium White + Cadmium Yellow Medium + Cerulean Blue + Green Grey

TRUNK AND BRANCHES
Warm Gray + Green Grey

1 Paint the Sky and Leaves

Paint the sky first, using a no. 20 mongoose filbert and random brushstrokes.

Pick up paint you've mixed for the tree's foliage on the flat bottom side of a palette knife and make strokes with light pressure. Gently lift the forward edge of the knife's blade as you spread the thick paint out from beneath. This method can be used for any tree you paint, not just those in foggy conditions.

2 Add Trunk and Branches

While the paint is still wet, put in the tree trunk and branches with either a palette knife or a no. 6 sable cat's tongue. If you use the palette knife, pick up enough color, then tilt the blade on its edge. By pushing and pulling the knife with light pressure, you can achieve a series of sharp and thin lines.

Paint the Seasons

In Ohio, where I live, the seasons are quite distinct.

Spring and Summer

The brilliant greens of spring are much appreciated after a long winter, but they're accompanied by a lot of rain and even tornadoes. Summer is sunny but very humid, and mosquitoes make painting outdoors a little less enjoyable.

Spring

The focus of this painting was the beautiful tree with its bright pinkish foliage, which turns to green in a very short time. That color is set off by the fresh brilliant green grass that is common here in the spring and especially on this golf course. The dirt around the tree awaits flowers to be planted. A hint of the pink color is repeated in the left background with the flowering crabapple trees.

Ohio Spring • *Oil on canvas* • *12" × 16" (30cm × 41cm)*

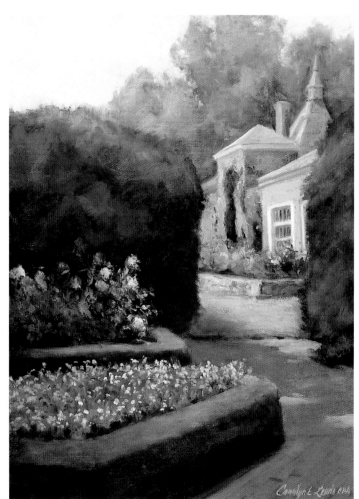

Summer

Combining architecture and flowers was a must, but the sunlight that hit the building and the pathway leading to that area made it become the main focal point.

Kingwood Center Gardens • *Oil on canvas* • *12" × 16" (30cm × 41cm)*

Autumn and Winter

The wide variety of tree species in Ohio makes for fall foliage ranging from yellows to rusty oranges to deep reds and crimsons. Some years, snow falls early, while the autumn leaves are still on the trees. Then winter arrives with mostly gray days—but nothing is more beautiful than freshly fallen snow clinging to every twig and branch on a sunny day.

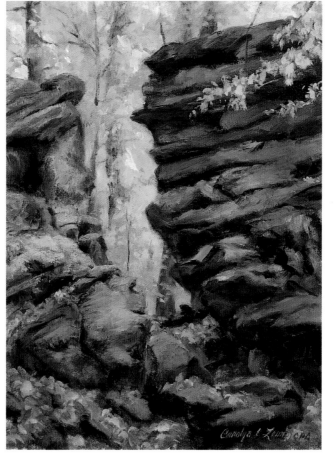

Autumn

I liked the contrast between the darker ledges and the bright orange and yellow leaves, and I added some accents of green as a complement.

Autumn Blaze • *Oil on canvas* • *16" × 12" (41cm × 30cm)*

Winter

This sunrise happened on a cold winter day. The snow and river reflected the yellow sky, and the shadows gave off a wonderful purple complement that I had to try to capture.

Along the River • *Oil on canvas* • *30" × 40" (76cm × 102cm)*

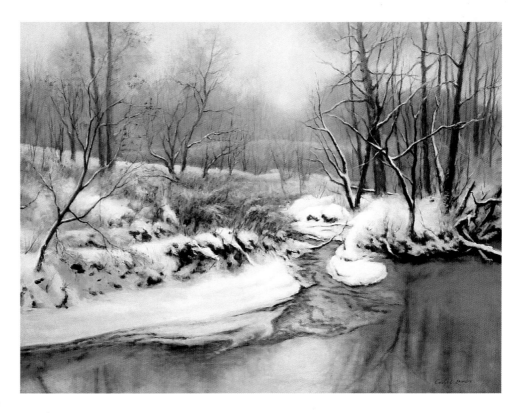

Autumn Color

The study for this painting was done on location in Colorado. The study gave me a lot of the value and color information that I needed for a studio painting.

Reference Photo

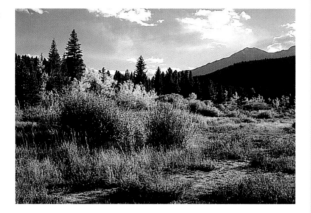

MATERIALS

PAINTS
Alizarin Crimson • Burnt Sienna • Cadmium Red Light • Cadmium Yellow Lemon • Cadmium Yellow Medium • Cold Gray • Naples Yellow • Neutral Grey • Phthalo Blue • Sap Green • Terra Rosa • Titanium White • Ultramarine Blue • Yellow Ochre

CANVAS
Stretched canvas or canvas board, 12" × 16" (30cm × 41cm)

BRUSHES
No. 6 bristle flat • no. 18 mongoose filbert • nos. 18, 14 and 10 mongoose brights • no. 4 sable bright

OTHER MATERIALS
Winsor & Newton Liquin

Study

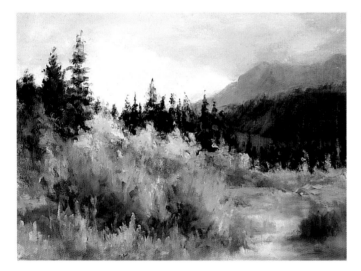

1 Sketch the Composition
Draw directly on a toned canvas with a no. 6 bristle flat using an earth tone color such as Yellow Ochre or Burnt Sienna.

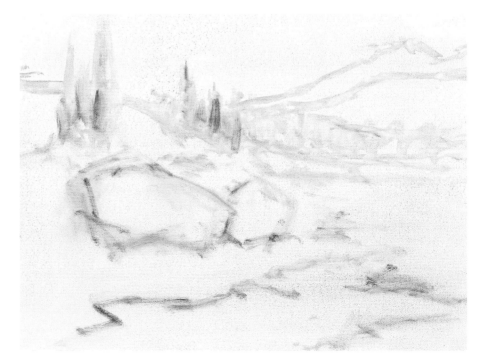

82

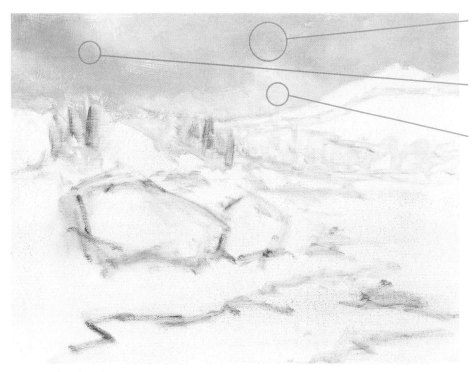

SKY
Titanium White + Phthalo Blue + Cadmium Red Light + Cadmium Yellow Medium

GRAY SHADOW AREAS OF CLOUDS
Cold Gray + Sky mixture above

CLOUDS
Titanium White + Cadmium Yellow Medium

2 Paint the Sky
Using a no. 18 mongoose filbert and a little Liquin if needed to help spread the paint, lay in the sky with random strokes, making it a little lighter toward the horizon. Next, lay in the clouds, starting with the shadows (use the same soft brush to avoid lifting the sky color).

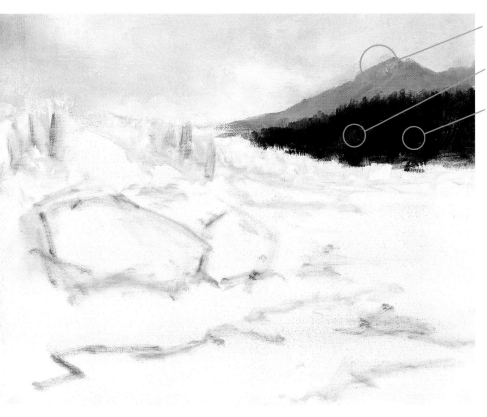

MOUNTAIN
Titanium White + Ultramarine Blue + Sap Green + Terra Rosa + Yellow Ochre

WARM PATTERN
Yellow Ochre

HILL
Cadmium Yellow Medium + Ultramarine Blue + Alizarin Crimson

3 Lay In the Mountain and Hill
Switch to a no. 18 mongoose bright. Lay in the distant mountain on the right, keeping its edges soft against the sky. Next, lay in the dark green hill in front of the mountain; use the side of the brush to create treetops. Blend the edges to give a misty look to the top of the hill. Add a warm pattern to the hill to resemble barren areas.

DARK GREEN PINES
Cadmium Yellow Medium + Ultramarine Blue + Cadmium Red Light

YELLOW BUSHES
Cadmium Yellow Medium

LIGHTER GREEN OF PINES
Add More Cadmium Yellow Medium to dark green pine mixture

RIDGE BETWEEN GREEN HILL AND PINES
Add Neutral Grey to light green mixture for pines.

4 Paint the Background Pine Trees
Put in darker colors first using a no. 10 mongoose bright. Add more Cadmium Yellow Medium to that mixture to make a lighter yellow-green color. For the little bit of ridge showing between the green hill and the pine trees, add some Neutral Grey to that lighter yellow-green color. Put in the bright yellow bushes in front of the pines.

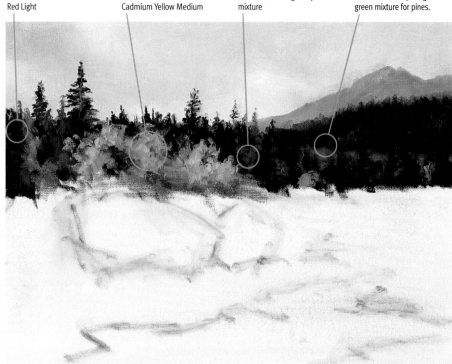

DARKS FOR BIG BUSHES IN FRONT
Cadmium Yellow Lemon + Ultramarine Blue + Burnt Sienna

MEDIUM VALUES FOR LARGE BUSHES
Titanium White + Cadmium Yellow Lemon + Ultramarine Blue + Cadmium Red Light

LIGHTER GREENS ON BIG BUSHES
Titanium White + Cadmium Yellow Medium + Neutral Grey

WARMER BUSHES IN BACK
Cadmium Yellow Medium + Burnt Sienna + Neutral Grey

LIGHT GREEN BUSHES
Titanium White + Cadmium Yellow Lemon + Phthhalo Blue + Neutral Grey

5 Lay In the Green Bushes
Lay in the green and warm bushes in front of the pine trees with a no. 14 mongoose bright. Add darks to the big bushes in the foreground with a no. 18 mongoose bright, using larger vertical strokes with the side of the brush. Add middle and lighter values to the bushes. Try not to make these areas too busy.

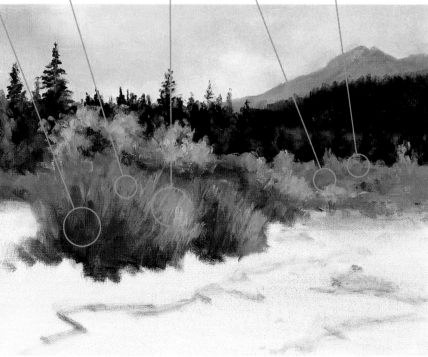

SHADOWS OF LARGE BUSHES
Burnt Sienna + Ultramarine Blue + Alizarin Crimson

SHADOWS FOR WEEDS
Yellow Ochre + Sap Green + Cadmium Red Light

WARM WEEDS
Naples Yellow + Cadmium Red Light

LIGHTER GREEN WEEDS
Titanium White + Cadmium Yellow Lemon + Ultramarine Blue + Cold Grey

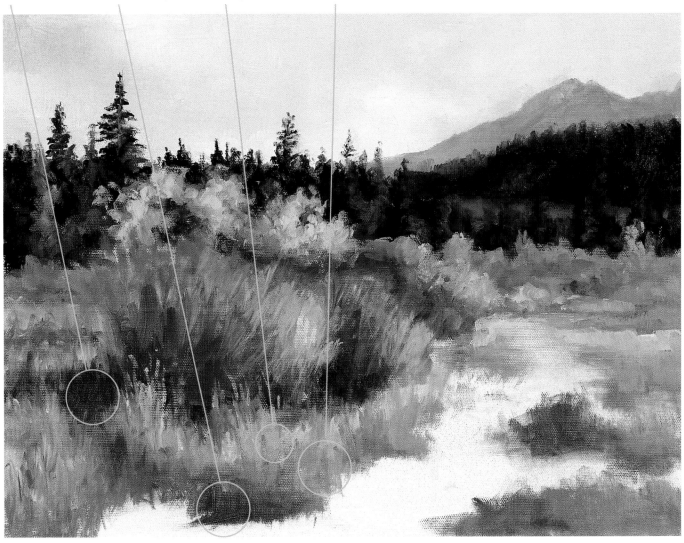

6 Paint the Brush and Weeds

Using a no. 14 mongoose bright, lay in all the weeds along the path, starting with the darker parts. Vary your strokes by using the side and tip of the brush. Add detail with a no. 4 sable bright. There are many subtleties of color in this land-scape with warm colors played against cooler green-grays.

7 Paint the Pathway

Put in the pathway with nos. 18 and 14 mongoose brights. Start with shadow areas and work your way up to the lightest areas. Stagger the weeds, and use mostly horizontal strokes to keep the path winding as it goes back in the distance.

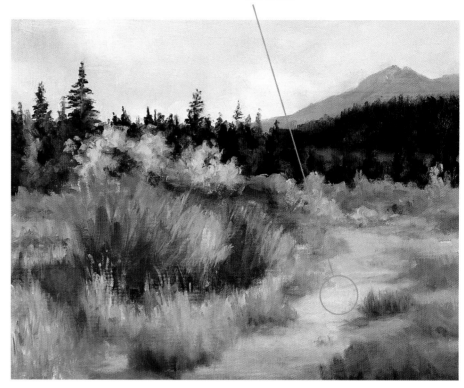

8 Make Minor Adjustments

If needed, adjust the spacing of weeds in the path to alleviate repetitiveness. Also adjust color temperatures if necessary so that everything harmonizes, as I did here in the two larger clumps of weeds on the left.

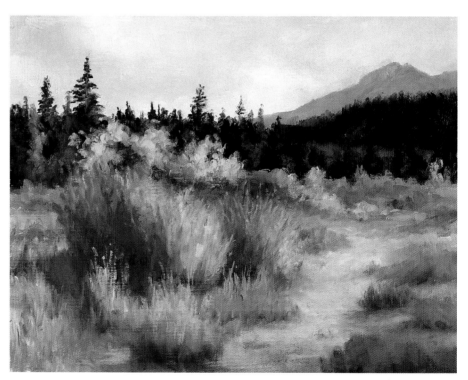

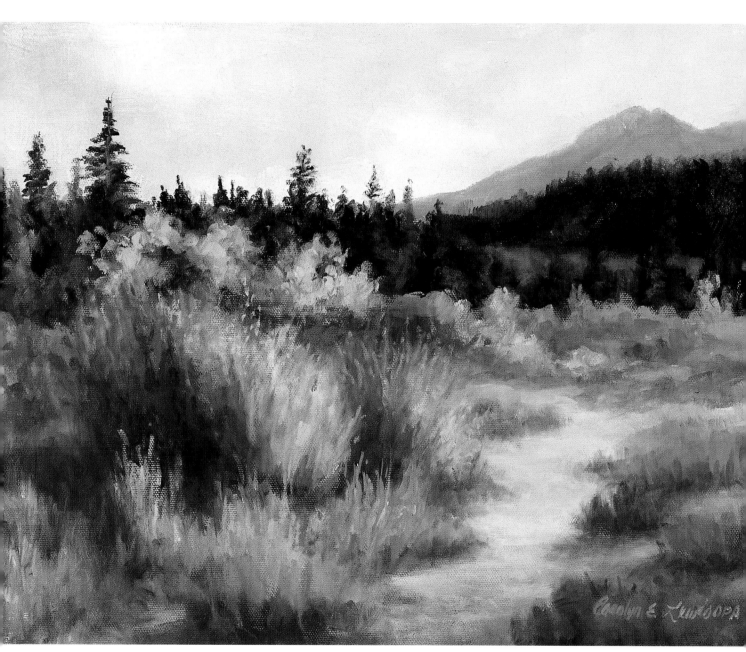

Autumn in Colorado • *Oil on canvas* • *12" × 16" (30cm × 41cm)*

Moving Water and Dappled Light

Since Yosemite's discovery in 1851, this glorious work of nature has attracted painters, writers, photographers, hikers and climbers. I felt privileged to be able to experience its beauty and to capture it on canvas.

Reference Photo

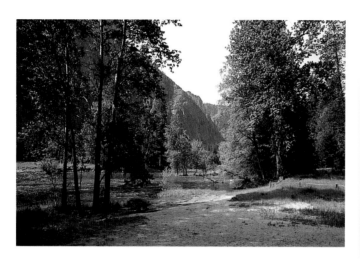

MATERIALS

PAINTS
Alizarin Crimson • Burnt Sienna • Cadmium Red Light • Cadmium Yellow Lemon • Cadmium Yellow Medium • Cold Gray • Green Grey • Naples Yellow • Neutral Grey • Phthalo Blue • Rose Grey • Sap Green • Titanium White • Ultramarine Blue • Yellow Ochre

CANVAS
Stretched canvas or canvas board, 18" × 24" (46cm × 61cm)

BRUSHES
No. 6 bristle flat • nos. 18 and 20 mongoose filbert • no. 18 mongoose bright • no. 12 badger bright • no. 8 sable cat's tongue • no. 4 sable filbert

OTHER MATERIALS
Winsor & Newton Liquin

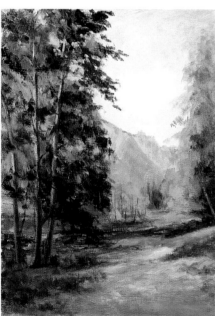

Study
After I did this oil sketch in a vertical format, I decided to paint in a horizontal format to better convey the vastness of the scene.

1 Sketch the Composition
Draw directly on a toned canvas with a no. 6 bristle flat and an earth tone color such as Yellow Ochre or Burnt Sienna.

SKY
Titanium White + Phthalo Blue + Cadmium Yellow Medium + Cadmium Red Light

CLOUDS (CORAL MIXTURE)
Titanium White + Cadmium Yellow Medium + Cadmium Red Light

CLOUDS (YELLOW MIXTURE)
Titanium White + Cadmium Yellow Medium

Paint the Sky

2 Using a no. 20 mongoose filbert and random strokes, lay in the sky. Use Liquin if needed. Then lay in clouds using the coral mixture followed by the light yellow mixture. Since the sky isn't the focal point, keep it soft and simple.

SHADOWS FOR MOUNTAINS
Burnt Sienna + Ultramarine Blue + Cold Gray

MOUNTAINS
Titanium White + Ultramarine Blue + Alizarin Crimson + Yellow Ochre

Paint the Mountains

3 Lay in mountains with a no. 20 mongoose filbert; know that the trees will cover most of this area. Use more Titanium White in the mixture where the value is lighter and put in darker areas on the bottom left. Don't worry about detail at this point; just lay in masses of local color. Keep your edges on the soft side when blending up into the sky.

MIDDLE VALUES OF TREES ON RIGHT
Titanium White + Cadmium Yellow Lemon + Ultramarine Blue

DARK PART OF TRUNKS
Burnt Sienna + Warm Gray

LIGHTER PARTS OF TRUNKS
Titanium White + Cadmium Yellow Medium + Cadmium Red Light + Neutral Grey

HIGHLIGHTS ON TREES ON RIGHT
Add more Titanium White + Cadmium Yellow Lemon to the middle-value mixture

DARKER AREAS FOR TREES ON RIGHT
Cadmium Yellow Lemon + Ultramarine Blue + Yellow Ochre + Burnt Sienna

DEAD PARTS OF LIMBS ON TREE ON RIGHT
Yellow Ochre + Cadmium Red Light + Burnt Sienna + Sap Green

4. Add the Trees

Put in the darks of the trees first and work your way up to the middle values; use a no. 20 mongoose filbert. For the smaller areas and highlights, use a no. 8 sable cat's tongue; use a no. 4 sable filbert for finer things like limbs.

BANK
Burnt Sienna + Yellow Ochre

DISTANT PINE TREE DARKS
Cadmium Yellow Medium + Ultramarine Blue + Cadmium Red Light

DISTANT PINE TREE LIGHTS
Titanium White + dark pine tree mixture

5. Paint the Distant Trees and Riverbank

As in step 4, put in darks first, then work up to the lights. Use a no. 18 mongoose bright for the largest areas, a no. 8 sable cat's tongue for midsized objects and a no. 4 sable filbert for smaller areas. There's no need to add much detail on the trees on the left, as they will be mostly covered by trees later.

Next, put in the riverbank and the grassy area. Add some tree trunks using the same colors as in Step 4.

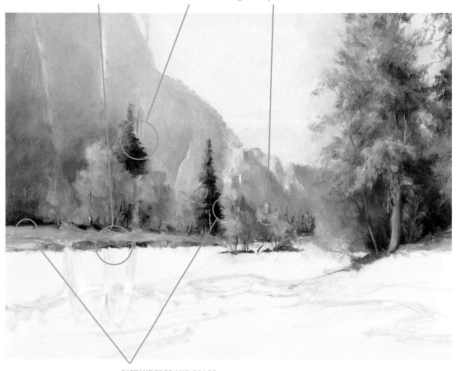

DISTANT TREE AND GRASS, COOLER LIGHTS
Titanium White + Green Grey + Cadmium Yellow Medium

RIVERBANK REFLECTIONS
Burnt Sienna + river colors

RIVER, BLUE GREENS
Sap Green + Ultramarine Blue + Cold Gray

HIGHLIGHTS
Neutral Grey + Sap Green

RIVER
Cadmium Yellow Medium + Ultramarine Blue + Cadmium Red Light

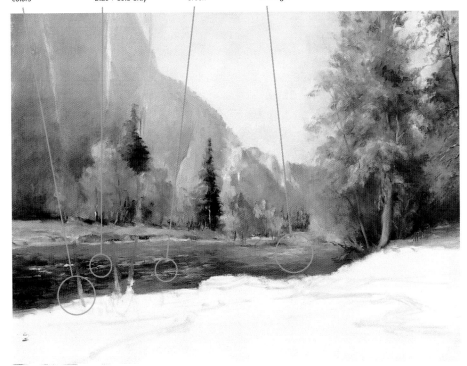

6 Paint the River

Using a no. 18 mongoose filbert, lay in the river using varying mixtures of the three colors shown.

Create reflections in the water by using some of the same colors as you used for the objects being reflected. Make the reflections of dark objects slightly lighter and the reflections of light objects slightly darker. First paint the colors vertically, then make horizontal strokes. Use a "lay it and leave it" approach for realistic reflections.

For the highlights on the water, use a no. 8 sable cat's tongue. Lay and leave the paint using short strokes with the side and tip of the brush. Use highlights sparingly; more is not always better.

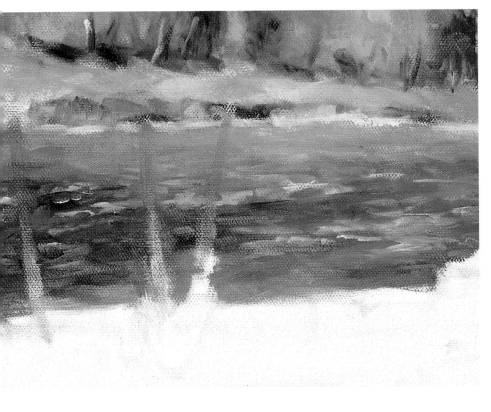

Detail: River Whitecaps

These little waves or whitecaps help give the river a sense of movement. Paint over, not around, the drawing of the tree trunks for a more flowing look. Then, if you want, wipe off a little paint where the tree trunks go.

Water depends partly on surrounding areas for its color, but the primary influence is its own local color. For instance, if the water is a deep olive green, all the colors reflected in it will be a little greenish. Paint water as you see it, not how you think it should look.

LIGHTER GREENS, FOREGROUND TREES	MIDDLE VALUE GREENS, FORE-GROUND TREES	TRUNKS, LIGHTS	DARKS, FORE-GROUND TREES	TRUNKS, MIDDLE VALUE	
Sap Green + Cadmium Yellow Lemon)	Cadmium Yellow Medium + Sap Green	Titanium White + Cadmium Yellow Medium + Cadmium Red Light + Neutral Grey	Cadmium Yellow Medium + Ultramarine Blue + Cadmium Red Light	Titanium White + Alizarin Crimson + Burnt Sienna + Ultramarine Blue	TRUNKS, DARK Cold Gray + Burnt Sienna

7 Paint the Foreground Trees

Put in the foliage first using a no. 12 badger bright, starting with the darks. Try to paint masses of color, not individual leaves, except for the very outside edges. Make interesting and varying shapes for the masses.

Next, paint the darks for the tree trunks. Don't make the trunks all the same. Try varying their thickness, color and value. Space them unequally; put one in front of another. For the thinner branches, use a no. 4 sable filbert.

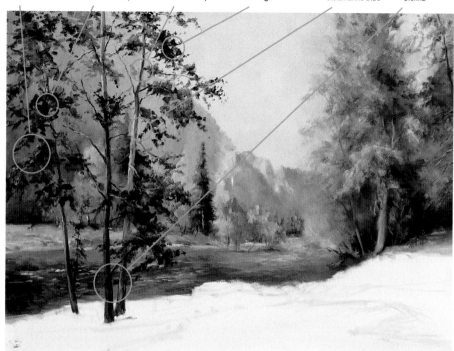

8 Paint the Foreground

Start with the shadows on the path; use a no. 20 mongoose filbert. Next lay in the dark greens, both warm and cool. Then add lighter colors and highlights to the path and grass. Show some texture in the grass by using the side of a no. 12 badger bright. When painting dappled light on a path, vary the size and location of the spots to avoid a repetitive and monotonous look.

DARK/WARM FOREGROUND	COOL GREENS, FOREGROUND	PATH SHADOWS	WARM GREENS, FOREGROUND	PATH LIGHTS	LIGHT GREENS, FOREGROUND
Burnt Sienna + Rose Grey	Sap Green + Cadmium Yellow Lemon	Naples Yellow + Alizarin Crimson + Ultramarine Blue	Sap Green + Cadmium Yellow Medium + Yellow Ochre	Titanium White + Naples Yellow + Cadmium Yellow Medium	Titanium White + Cadmium Yellow Lemon + Ultramarine Blue + Neutral Grey

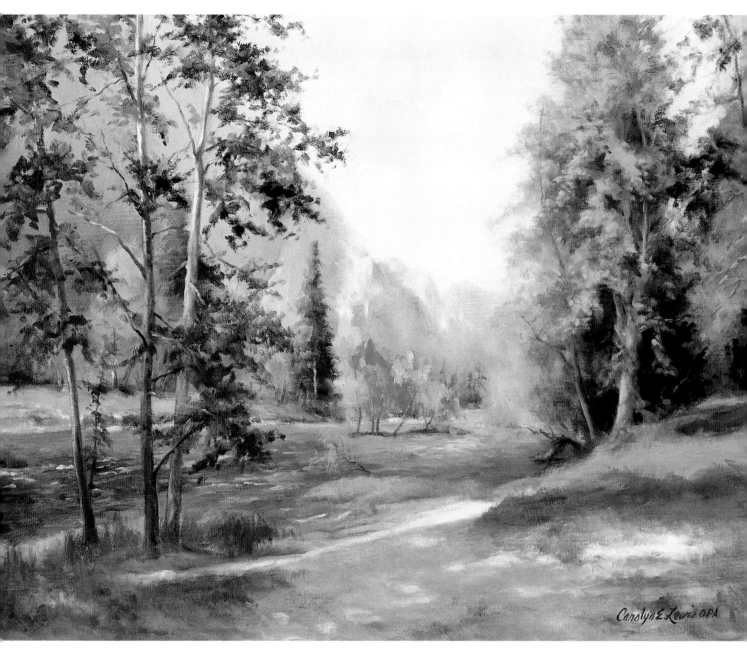

9 Make Final Adjustments

Work on anything that needs to be improved. Here, I brightened the sky and some of the trees, and I added highlights and more detail.

Yosemite Valley · Oil on canvas · 18" × 24" (46cm × 61cm)

Fast-Changing Weather

I did this late-afternoon study on location. I wanted to get the warm glow of the late sun against the white monastery. To my surprise, the fog rolled in behind the monastery and made the scene even more dramatic with its deep purples against the bright yellows.

Reference Photo

Study

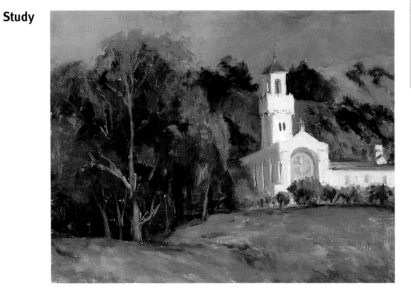

MATERIALS

PAINTS
Alizarin Crimson • Burnt Sienna • Cadmium Red Light • Cadmium Yellow Medium • Cold Gray • Monochrome Tint Warm • Naples Yellow • Neutral Grey • Permanent Rose • Sap Green • Terra Rosa • Titanium White • Ultramarine Blue • Yellow Grey • Yellow Ochre

CANVAS
Stretched canvas or canvas board, 12" × 16" (30cm × 41cm)

BRUSHES
No. 6 bristle flat • no. 18 mongoose filbert • no. 18 badger bright • no. 10 sable bright • no. 8 cat's tongue • no. 4 sable filbert

Sketch the Composition

1 Draw directly on a toned canvas with a no. 6 bristle flat and an earth tone color such as Yellow Ochre or Burnt Sienna.

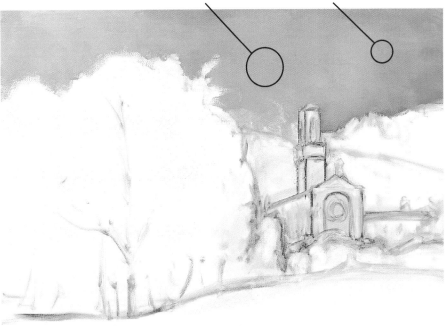

FOG (LIGHTER MIXTURE)
Titanium White + Cadmium Yellow Medium + Cadmium Red Light

FOG (DARKER MIXTURE)
Titanium White + Ultramarine Blue + Permanent Rose

Paint the Fog

2 With a no. 18 mongoose filbert and the two color mixtures, lay in the sky. Make it an ominous sky that will set the mood and later set off the monastery.

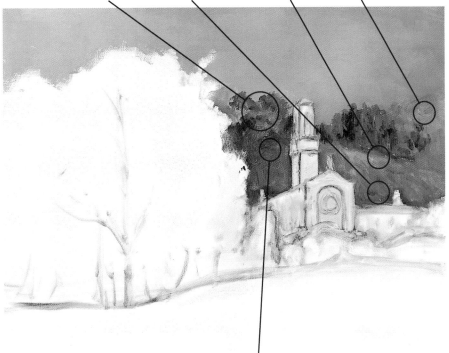

TREES
Cadmium Yellow Medium + Ultramarine Blue + Terra Rosa

MIDDLE HILL GREENS
Cadmium Yellow Medium + Ultramarine Blue + Monochrome Tint Warm

MIDDLE HILL YELLOWS
Cadmium Yellow Medium + Yellow Grey

DISTANT HILL
Titanium White + Cadmium Yellow Medium + Yellow Ochre + Cadmium Red Light

MIDDLE HILL REDS
Burnt Sienna + Cadmium Yellow Medium + Yellow Grey

Lay In the Trees and Distant Hill

3 Lay in the trees with the side of the no. 18 mongoose filbert. For the darker parts of the trees add a little more Ultramarine Blue and Cadmium Red Light to the tree mixture. Next, lay in the hill.

Put in the hill in front of the trees. To capture the smaller patterns of bushes on the hill, a no. 8 cat's tongue will help. For the tree trunks, use a no. 4 sable filbert. Remember, if your brush picks up the color from underneath, wipe the paint off the brush before continuing or you'll lose your fresh color. To avoid this problem, wait till the paint dries before putting in these elements.

PURPLE SHADOWS
Titanium White +
Ultramarine Blue +
Permanent Rose

**LIGHTS ON
MISSION WALL**
Titanium White +
Cadmium Yellow
Medium

CORAL SHADOWS
Titanium White + Cad-
mium Yellow Medium +
Cadmium Red Light

REDS ON ROOFS
Cadmium Red Light +
Alizarin Crimson + Cad-
mium Yellow Medium

4 Create Shadows on the Building

Using a no. 10 sable bright for larger areas and a no. 4 sable filbert for smaller details, put the shadows on the monastery. Use the purple mixture and add some of the coral mixture to tone it down some. The purple and the coral can also be used by themselves in some areas. Next, paint the whites of the monastery. Put in the door using a bit of the coral mixture lightened with more white. Finally, add the red roofs.

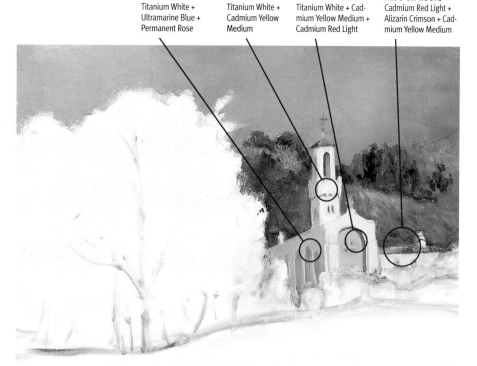

PINKISH BUSH
Titanium White + Cadmium
Red Light + Cadmium
Yellow Medium

DARK FOR BUSHES
Cadmium Yellow Medi-
um + Ultramarine Blue
+ Cadmium Red Light

REDDISH BUSHES
Yellow Ochre + Burnt
Sienna + Cadmium
Red Light + Sap
Green

**GRASS UNDER
BUSHES IN FRONT
OF MONASTERY**
Yellow Ochre + Burnt
Sienna

LIGHTS ON BUSHES
Cadmium Yellow
Medium + Sap Green +
Cadmium Red Light

5 Add the Bushes

The bushes are all different variations of green. Using the no. 10 sable bright, lay in the shadows under the bushes first, followed by the shadows on the bushes. Next, put in the lighter parts of the bushes. Last, lay in the reddish bushes. Wait till the paint dries, if necessary, before putting in trunks.

TREES ON FAR LEFT
Cadmium Yellow Medium + Terra Rosa + Neutral Grey

FOLIAGE FOR TREES
Cadmium Yellow Medium + Ultramarine Blue + Cadmium Red Light

LIGHTER PART OF TRUNKS
Naples Yellow + Cadmium Yellow Medium

DARKS IN TREES
Cadmium Yellow Medium + Alizarin Crimson + Sap Green

DARKER PART OF TRUNKS
Naples Yellow + Cadmium Red Light + Cadmium Yellow Medium

6 Paint the Trees on the Left

Start with a no. 18 badger bright and lay in the darks first. Then put in the middle greens. Using the same color combination but letting one primary dominate, you will get different greens. Paint in the warmer trees on the far left. Try keeping a rhythmic pattern going in your trees. Paint the trunks next. For detail, a no. 4 sable filbert can be used.

Detail of the Trees on the Left

In this detail, you can see how the light warmth of the branches plays against the darks of the foliage. Try to keep your brushwork loose. Don't mix the color you put down into the other colors, or you'll end up with mud.

**DARKER GREEN
AREAS, FOREGROUND**
Cadmium Yellow Medium
+ Ultramarine Blue +
Cadmium Red Light

**RUSTY COLOR IN
FOREGROUND**
Titanium White + Cadmium
Yellow Medium + Terra Rosa
+ Burnt Sienna

**LIGHTER GREEN AREAS,
FOREGROUND**
Naples Yellow + Cadmium
Yellow Medium + Ultramarine
Blue

Add the Foreground

Keep the foreground on the simple side, as the rest of
the painting is pretty busy. Using a no. 18 badger bright,
put down the different colors, using mostly horizontal strokes.

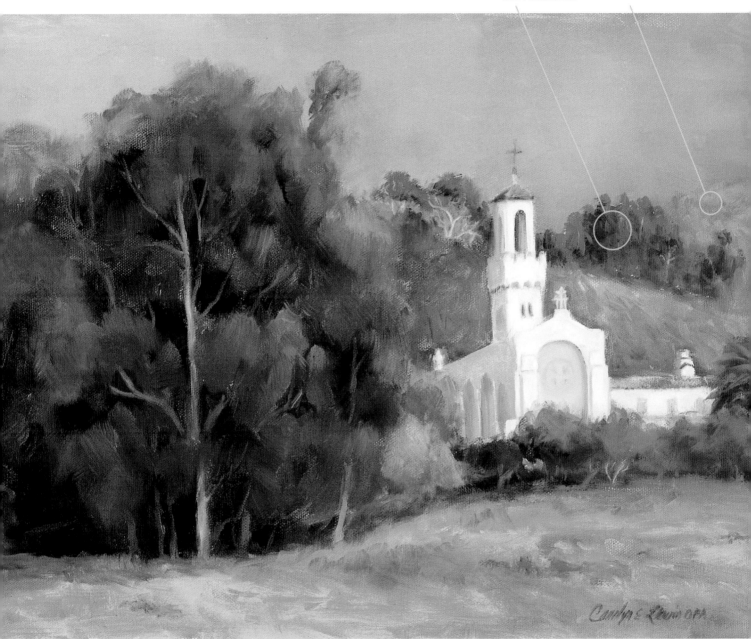

GRAYING DOWN OF MIDDLE HILL ON RIGHT
Yellow Ochre + Ultramarine Blue + Permanent Rose

GRAYING OF TREES ON DISTANT HILL ON RIGHT
Cold Gray + Ultramarine Blue

Carmelite Monastery • *Oil on canvas* • *12" × 16" (30cm × 41cm)*

8 Finish

Rework anything you need to change. The distant hills may need glazing to gray them down and push them back. Sometimes merely changing the value or the temperature is sufficient to correct things. Also, straighten anything that needs it, such as the church door or the cross. For small areas use a no. 4 sable filbert.

5

FROM PLEIN AIR TO THE STUDIO

It is essential for an artist to paint from life in order to understand light, color, values, shapes and edges. Only when we are out painting in the elements do we learn what nature gives us and how to capture it in the shortest time possible. This practice gives us artists a strict discipline of making quick and accurate decisions, which will enhance all painting endeavors.

Start each painting with a plein air study to get the proper shape and color relationships by painting large flat masses. You can accompany this with notes, pencil sketches or even photos for reference when you get back in the studio. There, take all this knowledge and make any changes or corrections necessary for a better painting. This makes for a valuable learning experience.

Flowers in the Piazza • Oil on canvas • 20" × 30" (51cm × 76cm) • *Private collection*

Paint From Photos

A camera cannot see the way our eyes do. Compared to what we see, the shadows in a photograph will generally be darker and the lights of the sky will be burned out. I can usually tell when artists have painted from photographs and copied exactly what they saw, blackened shadows and all. One has to learn to compensate for these faults of the camera, and that can't be done without observing life first. Just being there and observing, even when you can't paint, is better than using someone else's photograph. You can store this information in your memory or on a quick sketch.

When I have to take a photograph, I try to compose the image through the lens. I try to keep things from being cut in half vertically or horizontally, and I put the focal point where I want it to be. Since my camera has a manual control, I try to take one shot in the darker areas, like the shadows, and another in the lighter areas, like the sky. Between these two photos, I get a truer reading of color and value than I would from just one shot.

Photo of Lighter Areas
This shot was aimed at the sky and mountain, and the manual was adjusted control for this area. It made the mountain and sky look nice, but the shadows were too dark in the foreground trees and water.

Photos of Darker Areas
In this photo, I took a shot aimed more at the shadow area in the foreground. The shadows were lighter, but the sky and mountain were burned out.

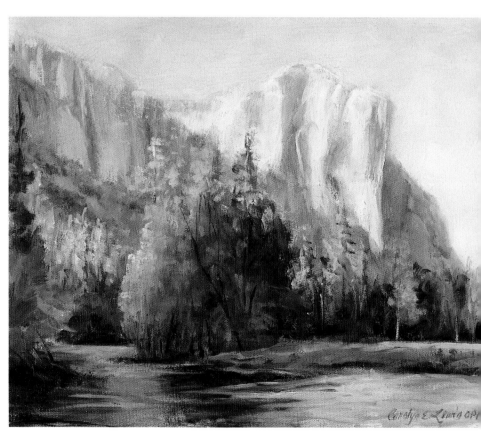

Combine Photographs for Greater Accuracy
Using the combination of the two photo references, I was able to get closer to the correct lighting and color that I observed in person.

El Capitan • *Oil on canvas board* • *11" × 14" (28cm × 36cm)*

Decide What to Eliminate From Photo References

When painting from a photograph, you must decide what to keep and what to leave out. As artists, we should improve on the photograph and make our paintings look even better. This may mean eliminating what isn't necessary or changing things around for a better design.

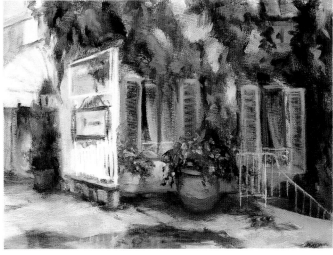

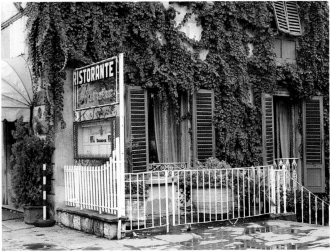

Color Study
To handle the flowerpots and the railing, I compromised by omitting the part of the railing in front of the flowerpots and keeping the rest.

Reference Photo
In this photo, the railing hid the beautiful flowerpots, which I wanted to feature, but I liked the railing also.

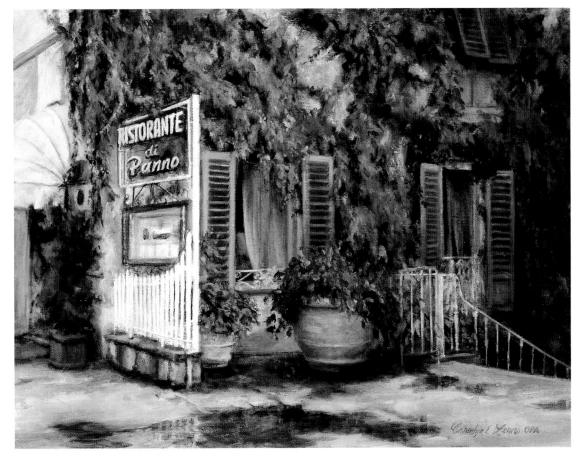

Finished Painting
In the final painting, I used the study as my guide and improvied the things I wanted to feature.

Ristorante di Panno • Oil on canvas • 12" × 16" (30cm × 41cm) • Private collection

Paint From Memory

Being able to paint from memory is crucial for plein air painting. Because sunlight changes so quickly, you have to adhere to your first observation and how you began to paint it. This first glimpse can be changed somewhat, but at some early point the artist must commit to a view, memorize that, and continue to paint it in that particular light.

To remember a scene, observe the shapes and try to name the colors you see. Another way to enhance your ability to paint from memory is to paint a particular subject repeatedly. When you focus on a subject for a long time, you will begin to remember its colors, shapes and values, and you won't have to rely on just a glance.

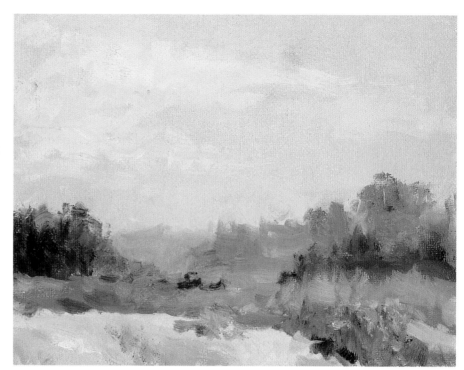

Think Shape and Color
I didn't paint these two studies on location; I painted them from memory. I memorized the scene by thinking of the shapes of the clouds and naming the colors I saw. Then I got a board and started to paint what I had just observed, making quick color notes.

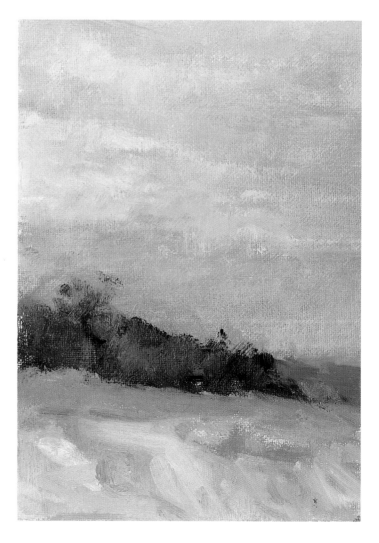

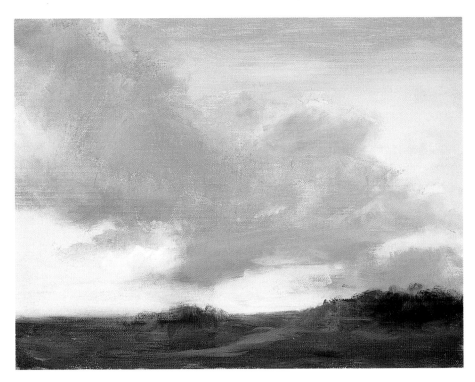

To Improve Your Memory and Observation Skills, Practice
These two studies were done the same way: by observing very carefully and painting as soon as possible while the scene was fresh in the memory. Painting the same scene more than once helps you remember it.

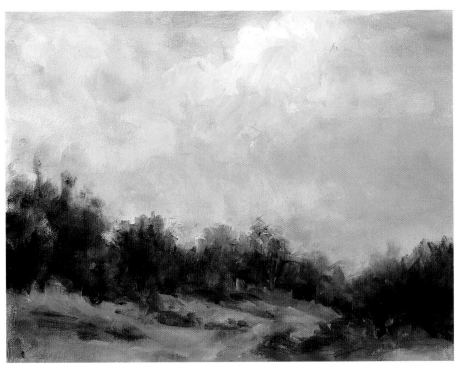

Take a New Look at an Old Scene

Like every artist, you probably have a lot of unfinished paintings and even some paintings that are complete but not "finished." As artists, we always want to grow and to do better, and we want our paintings to grow with us. You might change the design, content, light source, mood, values, color, temperature, edges, of an existing work, or you may decide it's better to start from scratch. Either way, you're likely to end up with a better painting when you use what you learned from the first attempt.

If you're not sure how to improve a painting, try getting new reference material to change your perspective on the scene, as I did in the example on these two pages.

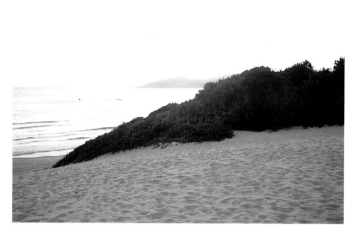

Reference Photo 1
In this photograph, the sky is too burned out and the sand appears darker than it actually was.

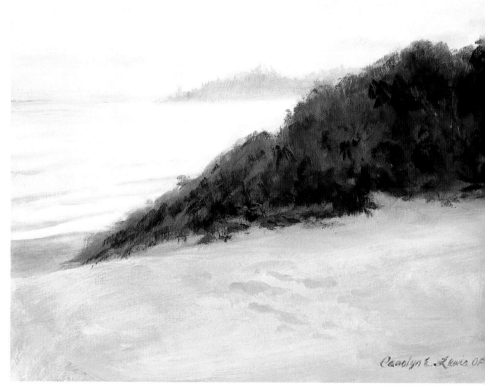

Painting 1
I liked the simplicity in this painting, but I felt it needed people or more greenery. Also, the diagonal shape of the bushes seemed to cut my canvas in half. I felt it could use some improvement.

Carmel Beach I • *Oil on canvas boar* • *9" × 12" (23cm × 30cm)*

Reference Photo 2

With this new photo, I now had more information to add to a new painting.

Carmel Beach II · *Oil on stretched canvas* · *9" × 12" (23cm × 30cm)*

Painting 2

Using the photo reference that had more bushes, I created a new, better painting of the same scene.

Simplify a Complex Scene

In this scene the ruins of an entire village had caught my interest, but at the same time, I didn't want to labor over them too much. Compare this reference photo to the finished painting on page 113 to see where I drew the line on trying to show detail.

MATERIALS

PAINTS
Alizarin Crimson • Burnt Umber • Cadmium Red Light • Cadmium Yellow Lemon • Cadmium Yellow Medium • Cold Gray • Green Grey • Monochrome Tint Warm • Naples Yellow • Neutral Grey • Permanent Rose • Phthalo Blue • Sap Green • Titanium White • Ultramarine Blue • Warm Gray • Yellow Grey • Yellow Ochre

SURFACE
Stretched canvas or canvas board

BRUSHES
No. 6 bristle flat • no. 18 badger bright • nos. 4, 8 and 20 mongoose bright • no. 20 mongoose sable filbert • no. 12 white bristle filbert

OTHER MATERIALS
Mineral spirits • Winsor & Newton Liquin

Reference Photo

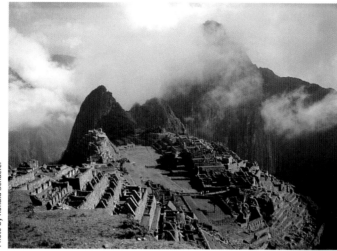

Photo by Ronald Schaefer

1 Sketch the Composition
Draw directly on a toned canvas with a no. 6 bristle flat and an earth tone color such as Yellow Ochre.

**DARK MOUNTAIN
ON LEFT**
Burnt Umber + Cold
Gray + Ultramarine Blue
+ Alizarin Crimson

**GROUND IN FRONT
OF LEFT MIDDLE
MOUNTAIN**
Cold Gray + Sap Green
+ Burnt Umber

**DISTANT MOUNTAIN
ON RIGHT**
Cold Gray + Neutral
Grey + Yellow Ochre

2 Lay In the Distant Mountains
Working from dark to light, lay in the darker parts of the mountains, using a no. 12 white bristle filbert and some mineral spirits to keep the paint thinner at first.

For the middle to lighter values use the same three colors, but use more of the Neutral Grey and less of the Cold Gray and Yellow Ochre. Put down the strokes in the same direction the ridges in the mountain appear.

This is all just a basecoat, most of which will be gone over later.

**GREEN AREAS,
MIDDLE MOUNTAIN**
Green Grey + Cadmium Yellow
Lemon + Cold Gray

**DISTANT HILL,
DARKER PARTS**
Green Grey + Yellow
Grey + Titanium White
+ Alizarin Crimson

SKY
Titanium White
+ Phthalo Blue
+ Cadmium
Yellow Medium

**TOP OF DISTANT
MOUNTAIN ON
FAR LEFT**
Cold Gray +
Titanium White

**LIGHT PARTS
OF CLOUDS**
Titanium White
+ Cadmium
Yellow Medium

**CORAL PARTS OF
CLOUDS**
Titanium White + Cad-
mium Yellow Medium
+ Cadmium Red Light

**DISTANT HILL,
LIGHTER PARTS**
Green Grey +
Yellow Grey +
Titanium White

DARKER GRAY CLOUDS
Titanium White + Ultramarine Blue + Permanent Rose +
Cadmium Yellow Medium

WARMER PARTS OF HILL
Yellow Grey + Cadmium Red Light

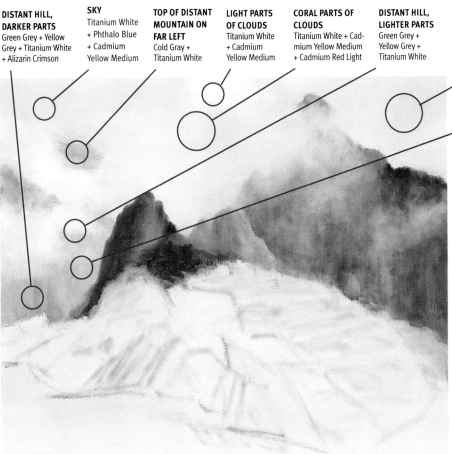

**3 Lay In the Sky and the Distant
Mountain on the Far Left**
Using a no. 20 mongoose sable filbert, lay in the blue of the sky. Next, put in the distant mountain on the far left. For smaller areas, use the side of the brush.

Put in the clouds, painting from dark to light, always checking values to make sure they're correct. Some of the warmth of the toned canvas can show through for a nice touch. The clouds have many subtleties in color as well as soft edges feathering out. Work thinly, dragging color over the face of the mountain for a wispy look. All this will give a great atmospheric quality.

DARK WARM GRAYS
Warm Gray + Yellow
Ochre

LIGHTER AREAS
Monochrome Tint
Warm + Titanium White

COOLER DARKS
Cold Gray + Neutral Grey
+ Yellow Ochre

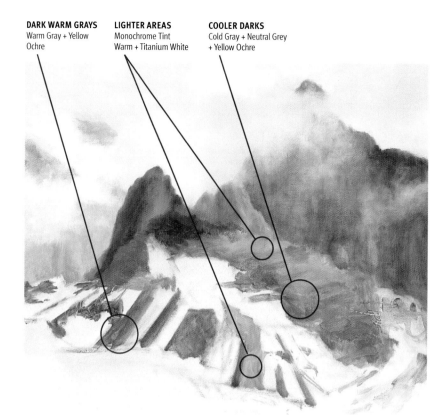

Lay In the Middle-Value and Dark Shapes of the Ruins

4 Look for general shapes and patterns of the ruins, and lay the paint on thinly using a no. 18 badger bright. Keep it simple; do not focus too much on detail.

WARMER AREAS OF GRASS
Naples Yellow + Yellow
Ochre + Cadmium Red Light

BUSHES
Cadmium Yellow Medium
+ Ultramarine Blue +
Cadmium Red Light

GREENER AREAS
Green Grey + Cadmium
Yellow Medium

Add the Grassy Areas

5 Using a no. 20 mongoose sable filbert, loosely fill in grassy areas and bushes. Add Liquin or mineral spirits to the paint to help thin it down for this first layer.

110

WARM DARKS ON WALLS
Warm Gray

LIGHT PARTS OF WALLS
Yellow Grey + Naples Yellow

HIGHLIGHTS
Neutral Grey + Naples Yellow

COOLER DARKS OF WALL
Cold Gray + Alizarin Crimson + Yellow Ochre

6 Add Detail to the Ruins on the Left
Start to break up all the larger shapes you made for the buildings. Do this by slowing down and looking carefully to see where the shadows and lights of the ruins meet. Be careful to keep the right values and angles. Using a no. 8 mongoose bright for the larger areas and a no. 4 mongoose bright for the smaller ones, put in the darker parts first and gradually work up to the lights.

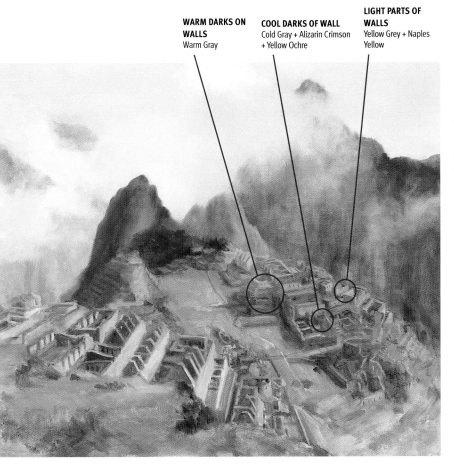

WARM DARKS ON WALLS
Warm Gray

COOL DARKS OF WALL
Cold Gray + Alizarin Crimson + Yellow Ochre

LIGHT PARTS OF WALLS
Yellow Grey + Naples Yellow

7 Suggest Ruins on the Right
Using the same brushes and color combinations, suggest the shapes of buildings, just like you did on the left side. Since these ruins are slightly farther away than the ones on the left, make them a little cooler and grayer by using more gray in the mixes and some Titanium White to lighten if needed.

111

8 Perfect the Ruins on the Left

Using basically the same colors and brushes, modify and perfect the buildings until you are satisfied. Suggest some windows or doorways and texture in the walls, making everything crisper and brighter. Add any highlights you may have left out.

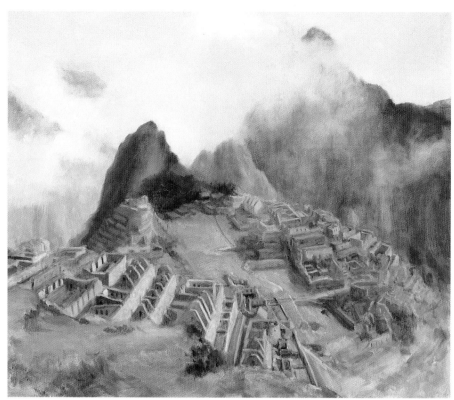

Detail of Buildings on Left

This shows a close-up of the buildings on the left. Since many variations of grays are used in this painting, start with a gray and add color where needed. Keep the buildings on the loose side but paint enough detail to suggest realism without getting too tight.

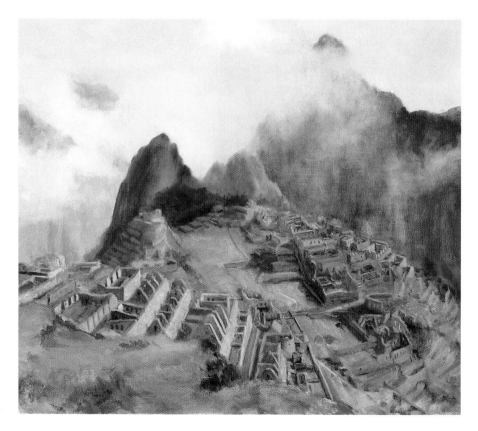

9 Perfect the Ruins on the Right

Using the same techniques and materials you did for the ruins on the left, modify and perfect the ruins on the right. Try to keep them from having as much contrast as the ones on the left.

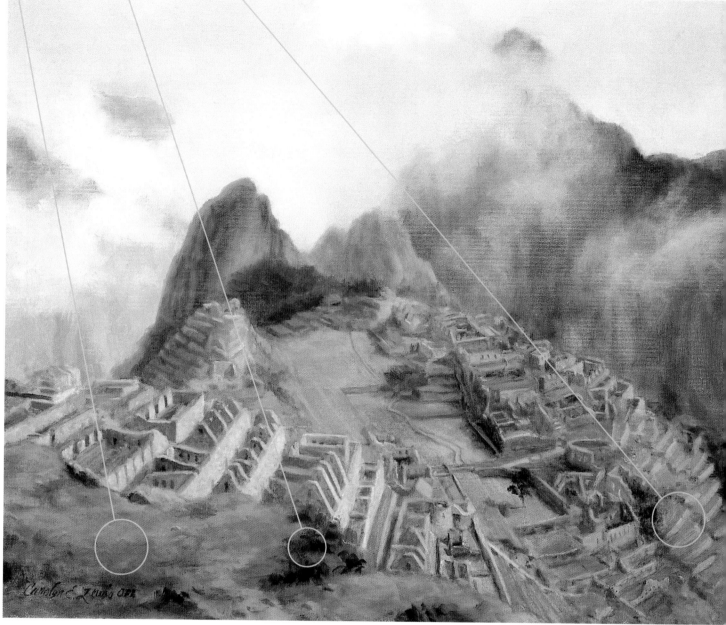

FOREGROUND
Yellow Ochre + Alizarin Crimson + Neutral Grey

BUSHES
Cadmium Yellow Medium + Ultramarine Blue + Cadmium Red Light

COOLER GRASS
Green Grey + Cadmium Yellow Medium

10 Finish the Foreground

Using a no. 20 mongoose bright for larger areas, put in the bushes and grass of the foreground. Then, finish suggesting walls and grass in the lower-right foreground. For the smaller areas, use a no. 8 mongoose bright, and for fine details use a no. 4 mongoose bright.

Inca Ruins of Machu Picchu • Oil on stretched canvas • 20" × 24" (51cm × 61cm)

Paint a Winter Scene

In this early-morning winter scene, the yellow sky reflecting on the snow makes for a different mood than the cold bluish tones one usually associates with winter. An unseen river behind the tree created the mist on the distant trees.

MATERIALS

PAINTS
Alizarin Crimson • Burnt Sienna • Burnt Umber • Cadmium Red Light • Cadmium Yellow Medium • Cold Gray • Grey of Grey • Neutral Grey • Permanent Rose • Sap Green • Titanium White • Ultramarine Blue • Warm Gray • Yellow Grey • Yellow Ochre

SURFACE
Stretched canvas or canvas board

BRUSHES
no. 6 bristle flat • no. 4 kolinsky sable filbert • no. 18 mongoose bright • no. 10 sable cat's tongue • no. 20 sable filbert

OTHER MATERIALS
Winsor & Newton Liquin

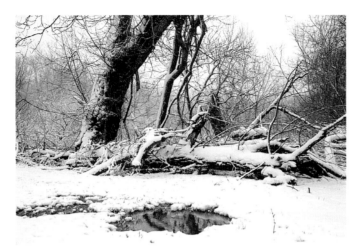

Reference Photo
I knew I would need to simplify the background of this scene in order to bring out the foreground in my painting. Also, the photo was bluer than my recollection of the scene, so I painted the warmer, yellower tones I remembered.

1 Sketch the Composition
Draw directly onto a toned canvas with a no. 6 bristle flat and an earth tone color such Yellow Ochre or Burnt Sienna.

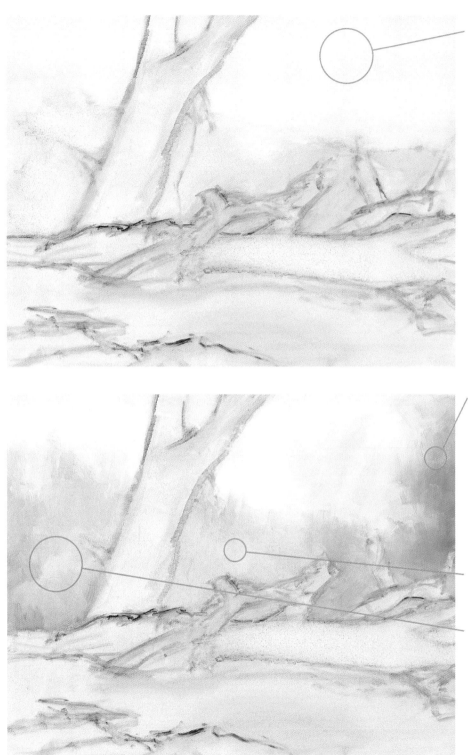

LIGHT YELLOW MIXTURE
Titanium White + Cadmium
Yellow Medium

2 Paint the Sky
Using a 1-inch (25mm) glaze brush, Liquin and random strokes, put in the sky. This early-morning sky is pastel in color.

DARKS IN BACKGROUND
Yellow Ochre + Ultramarine
Blue + Cadmium Red Light +
Titanium White

BACKGROUND TREES
Titanium White + Cadmium
Yellow Medium + Yellow Grey

OTHER DARKS
Yellow Ochre + Ultramarine
Blue + Alizarin Crimson + Tita-
nium White

3 Lay In the Background Trees
Using a no. 20 sable filbert, lay in the background trees. Make them slightly darker in value than the sky. Use the side of your brush at times, feathering up into the sky without getting too definitive. Make the background bush a little darker.

DON'T HESITATE TO MAKE IMPROVEMENTS

I changed the position of the tree stump on the right in the background. I felt it was too close to the other one and formed an inverted V, causing tension I didn't want within the painting. By making the tree stump taller and graying it down more, I took it back in the distance, making it less important. Don't be afraid to improve your paintings in midstream when needed.

4 **Lay In the Darks and Shadows of the Tree**
With a no. 18 mongoose bright, lay in the darks of the trees, using not only the flat part of the brush but also the side, making softer edges against the background. Suggest jagged edges and the texture of bark. You can also work negatively by lifting off some of the paint, showing the reflective color on the tree by using the more golden color underneath. Lay in the shadow under the fallen tree. Then put the puddles in the foreground—one is mostly grass where the snow has melted, but the other has water.

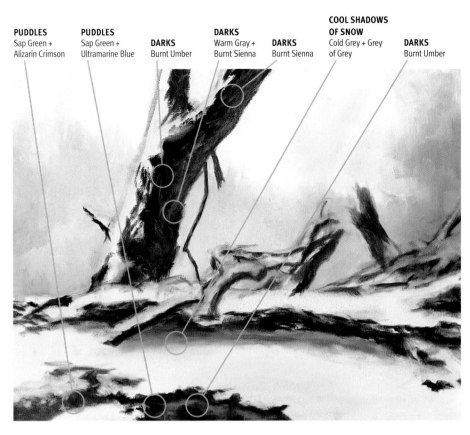

PUDDLES
Sap Green + Alizarin Crimson

PUDDLES
Sap Green + Ultramarine Blue

DARKS
Burnt Umber

DARKS
Warm Gray + Burnt Sienna

DARKS
Burnt Sienna

COOL SHADOWS OF SNOW
Cold Grey + Grey of Grey

DARKS
Burnt Umber

5 **Lay In Snow and Shadows**
Wait until the darks from Step 4 dry before painting the snow in this step, or you will have light brown snow.
Lay in the general shapes of the shadows on the snow using a no. 18 mongoose bright for the larger parts and a no. 4 kolinsky sable filbert for the smaller areas. Save the smaller twigs for later. Since the sunlight is soft behind the morning mist, the contrast between light and shadow in the background is not strong. The greatest contrast of color occurs between the tree and the snow. There are more subtle shadows within the snow.

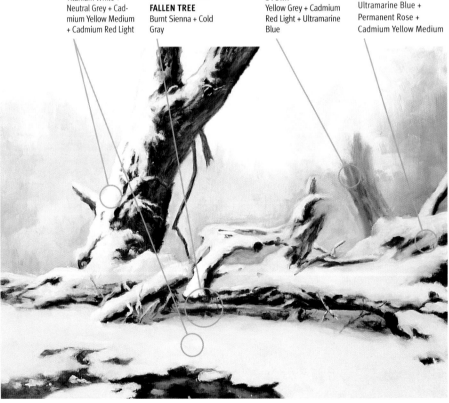

LIGHTER SNOW
Titanium White + Neutral Grey + Cadmium Yellow Medium + Cadmium Red Light

GROUND UNDER FALLEN TREE
Burnt Sienna + Cold Gray

LIGHTER PARTS ON STUMP
Yellow Grey + Cadmium Red Light + Ultramarine Blue

SHADOWS IN SNOW
Titanium White + Ultramarine Blue + Permanent Rose + Cadmium Yellow Medium

BRANCHES AND TREES
Burnt Umber + Neutral Grey +
Ultramarine Blue

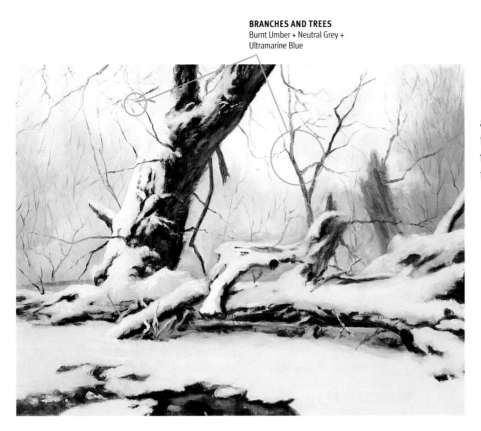

6 **Lay In Branches and Trees**
Starting at the top of the painting and working down, lay in branches and trees with a no. 4 kolinsky sable filbert. Hold your brush near the end of the handle so that your stroke will be flowing and not too tight.

SNOW ON BRANCHES IN BACKGROUND
Titanium White + Ultramarine Blue + Permanent
Rose + Cadmium Yellow Medium

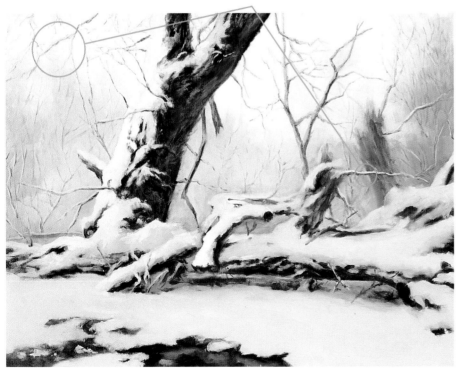

7 **Lay In Snow on Background Branches and Trees**
After the paint has dried from Step 6, use a no. 10 sable cat's tongue to lay in the lighter snow on the branches and trees in the background.

8 Add Details to the Puddles and Grass

Using a no. 4 kolinsky sable filbert for smaller areas, first put in the shadows of the snow around the puddles and make the indentations in the snow where grass is growing through. Suggest some grass growing around the edges of the puddle and up out of the shadow indentations. Use the side of the brush for the larger areas. Next use the tip of the brush and go from the bottom up to create the blades of grass. Avoid making the grass too busy or too evenly spaced; paint just enough to get the effect. Try to establish a nice pattern leading back to the large tree.

GRASSY AREAS
Sap Green + Ultramarine Blue + Burnt Sienna

SHADOWS OF SNOW
Grey of Grey

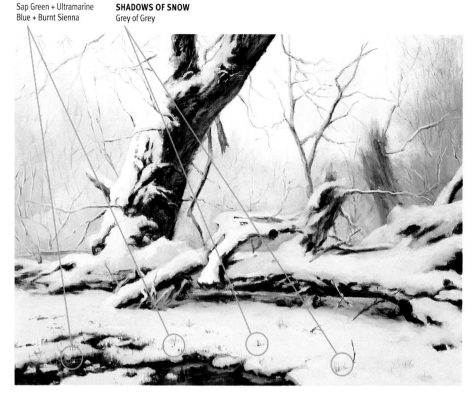

Detail

This close-up shows the texture brought out in the tree. It may take some working back and forth with the brown of the trunk and the white of the snow to get it right. If you want to break up some of the snow, wait till it's dry, and then work with negative shapes of the dark tree into the snow (or vice versa if you have too much tree).

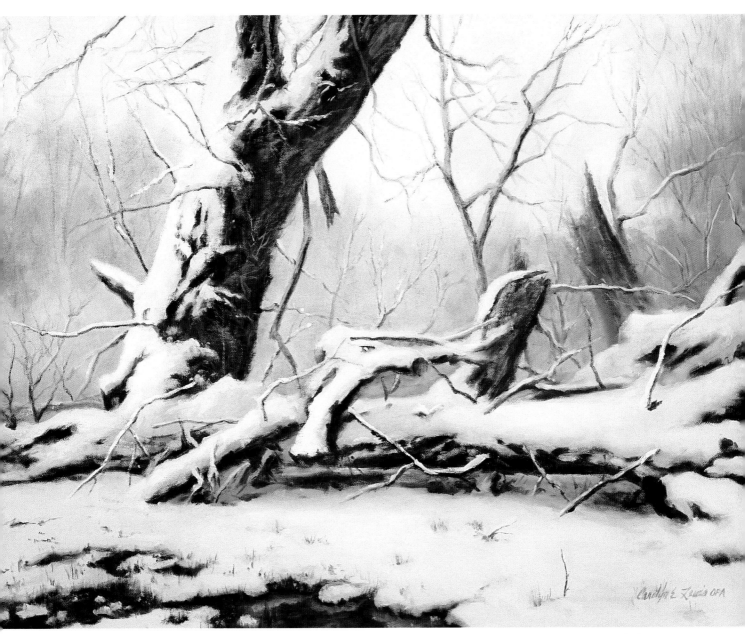

9 Fine-Tune the Painting

Work on anything that needs to be changed or enhanced. (If the painting is dry, put on a very light coat of Liquin first.) Eliminate anything that takes away from the painting, and add anything that would help it. Also make sure values and colors are correct and read well and that the shapes have enough areas of lost and found edges between them (see page 20 for more on lost and found edges).

Winter Morning · Oil on stretched canvas · 18" × 24" (46cm × 61cm)

Paint From a Different Perspective

Usually one sees panoramic images of the Grand Canyon from above, but I thought I would provide a different view by painting it vertically and from below. I used a palette knife for a good portion of this painting.

MATERIALS

PAINTS
Alizarin Crimson • Burnt Sienna • Burnt Umber • Cadmium Red Light • Cadmium Yellow Lemon • Cadmium Yellow Medium • Cerulean Blue • Cold Gray • Coral Red • Green Grey • Grey of Grey • Monochrome Tint Warm • Naples Yellow • Neutral Grey • Permanent Rose • Phthalo Blue • Rose Grey • Sap Green • Titanium White • Ultramarine Blue • Yellow Grey • Yellow Ochre

SURFACE
Stretched canvas or canvas board, 24" × 18" (61cm × 46cm)

BRUSHES
No. 6 bristle flat • nos. 8 and 12 badger bright • nos. 18 and 20 mongoose bright • no. 6 and 8 sable cat's tongue

OTHER MATERIALS
Palette knife

Reference Photo
The photo is dark and rather blue. I adjusted the values and colors for my painting.

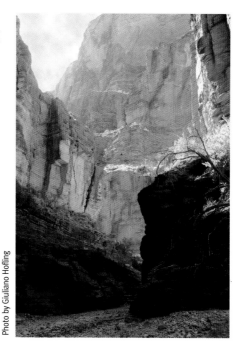

Photo by Giuliano Hofling

1 Sketch the Composition and Begin to Lay In Shapes
Draw directly onto a coral-toned canvas with a no. 6 bristle flat and an earth tone color such Yellow Ochre or Burnt Sienna. Then lay in the two dark foreground rocks.

SKY
Titanium White + Phthalo Blue + Cadmium Yellow Medium

CLOUDS
Titanium White + Cadmium Yellow Medium + Permanent Rose

2 Lay In the Sky
Using a no. 18 mongoose bright, lay in the sky and some clouds. Keep the clouds simple, as the rest of the painting will be busy enough.

CORAL GRAYS
Coral Red + Neutral Grey

WARM LIGHTS
Titanium White + Yellow Grey

DARKER GRAY
Titanium White + Permanent Rose + Cold Grey

ROSE GRAYS
Rose Grey + Neutral Grey

3 Lay In the Mountain
With a no. 20 mongoose bright, add the mountain, starting with the crevices. Since this mountain is distant, use soft edges and not too much texture. Suggest ridges using warm lights applied with a palette knife.

COOLER PARTS
Titanium White +
Ultramarine Blue
+ Coral Red

LIGHTER PARTS
Naples Yellow +
Titanium White

GREENS
Titanium White +
Cadmium Yellow
Lemon +
Cerulean Blue

CREVICES
Burnt Umber +
Alizarin Crimson

CORAL PARTS
Coral Red +
Grey of Grey

HIGHLIGHTS
Naples Yellow + Titanium
White + Rose Grey

MIDDLE VALUES
Titanium White + Cadmium
Yellow Medium + Cadmium
Red Light + Rose Grey

DARKS AND CREVICES
Sap Green + Alizarin
Crimson + Naples Yellow

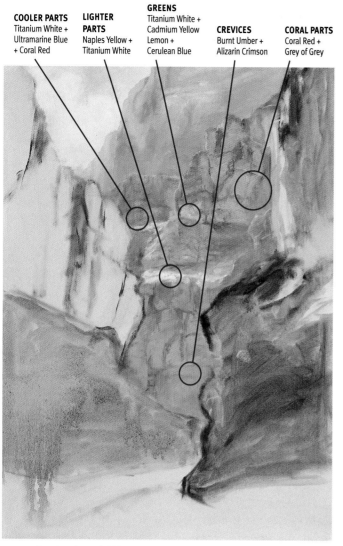

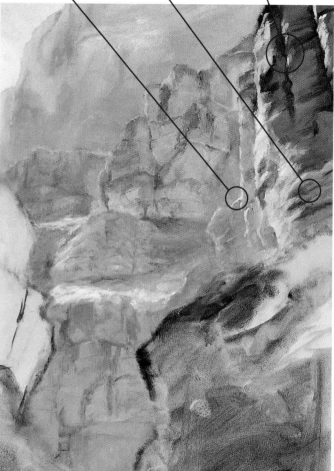

4 **Put In the Middle Rocks**
Using a no. 20 and a no. 18 mongoose bright and a palette knife, put in the middle rocks. Lay in the crevices first, then add the rest by following the angles of the rock layers. Use a no. 8 badger bright to add any detail, like the green matter.

5 **Add the Rocks on the Top Right**
Paint the crevices first with a no. 8 badger bright. Then, using a no. 20 mongoose bright or a palette knife, put in the darks of each area. Start with the ledge farthest back and work forward up to the lights. Keep in mind that these rocks should be more detailed than the ones in step 4 but less detailed than the ones in the foreground.

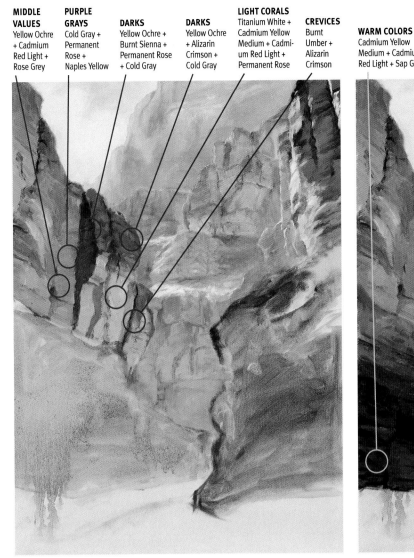

MIDDLE VALUES
Yellow Ochre + Cadmium Red Light + Rose Grey

PURPLE GRAYS
Cold Gray + Permanent Rose + Naples Yellow

DARKS
Yellow Ochre + Burnt Sienna + Permanent Rose + Cold Gray

DARKS
Yellow Ochre + Alizarin Crimson + Cold Gray

LIGHT CORALS
Titanium White + Cadmium Yellow Medium + Cadmium Red Light + Permanent Rose

CREVICES
Burnt Umber + Alizarin Crimson

WARM COLORS
Cadmium Yellow Medium + Cadmium Red Light + Sap Green

SHADOWS AND CREVICES
Burnt Umber + Alizarin Crimson

MIDDLE DARKS
Yellow Ochre + Alizarin Crimson + Cold Gray

BLUE DARKS
Cold Gray + Ultramarine Blue

MIDDLE DARKS
Rose Grey

6 Put In the Rocks at the Top Left

Use a no. 8 badger bright or a palette knife to paint the crevices. Then, using a palette knife or a no. 20 mongoose bright, lay in the darks, the middle tones and the highlights. Working with the palette knife first and then softening some edges with the brush may be most effective for this. Show more texture here. Then, glaze some purple grays over the rocks in some areas.

7 Add the Rocks at the Bottom Left

Using a no. 20 mongoose bright and starting with the darks again, lay in the local colors. Once all your values are correct, lay the paint on a little heavier with palette knife or the same brush. Use the side of the brush to get in the smaller areas. Try to lay it and leave it—do not overmix one color into another.

DARKS ON ROCKS
Burnt Sienna + Cadmium Yellow Medium + Cadmium Red Light

GREENS ON ROCKS
Green Grey + Sap Green + Cadmium Red Light

GREEN FOLIAGE
Cadmium Yellow Lemon + Ultramarine Blue + Cadmium Red Light

HIGHLIGHTS, WEEDS, LIMBS
Naples Yellow + Grey of Grey

LIGHT PART, ROCKS
Naples Yellow + Rose Grey

LIMBS
Burnt Umber

DARKS
Cadmium Yellow Medium + Cadmium Red Light + Ultramarine Blue

WARMER COLORS
Monochrome Tint Warm + Cadmium Red Light

COOL COLORS
Grey of Grey + Cold Gray + Alizarin Crimson

CORAL PARTS
Naples Yellow + Cadmium Red Light + Ultramarine Blue

GREENS
Cadmium Yellow Lemon + Ultramarine Blue + Cadmium Red Light

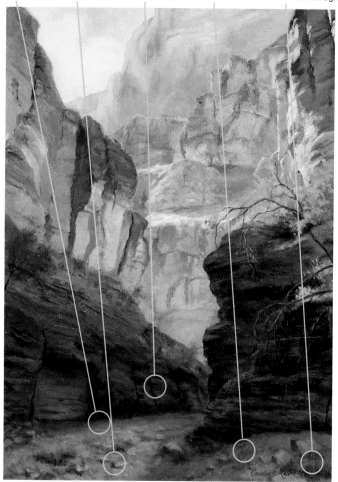

8 Put In the Rocks at the Lower Right

With a no. 20 mongoose bright or a palette knife, lay in the rocks. First use the different darks toput in the rock farthest to the back. Then, follow the angles and direction of the layers of rock to add the rest of the rocks. Depending on how thick the paint is, the paint may need to dry before you lay in the middle tones and lighter values. For the foliage, use a no. 12 badger bright; use a no. 6 sable cat's tongue for the limbs.

DARKS ON ROCKS
Burnt Umber + Alizarin Crimson

BLUES ON ROCKS
Cold Gray + Ultramarine Blue

9 Paint the Ground

Use a no. 20 mongoose bright to loosely lay in the ground. Suggest stones and rocks starting with the darks. Bring the large, dark rocks into the ground area and vice versa so you won't make just a hard, straight line between the two. Look for simpler patterns, and try not too overdo the detail. For grass and smaller rocks, use either a no. 12 badger bright or a no. 8 sable cat's tongue. Correct anything that needs to be fixed. Here, I changed the extreme V shape the sky made by extending the distant mountain to the left more, and I toned down the greens in the foliage.

The finished painting is on the next page.

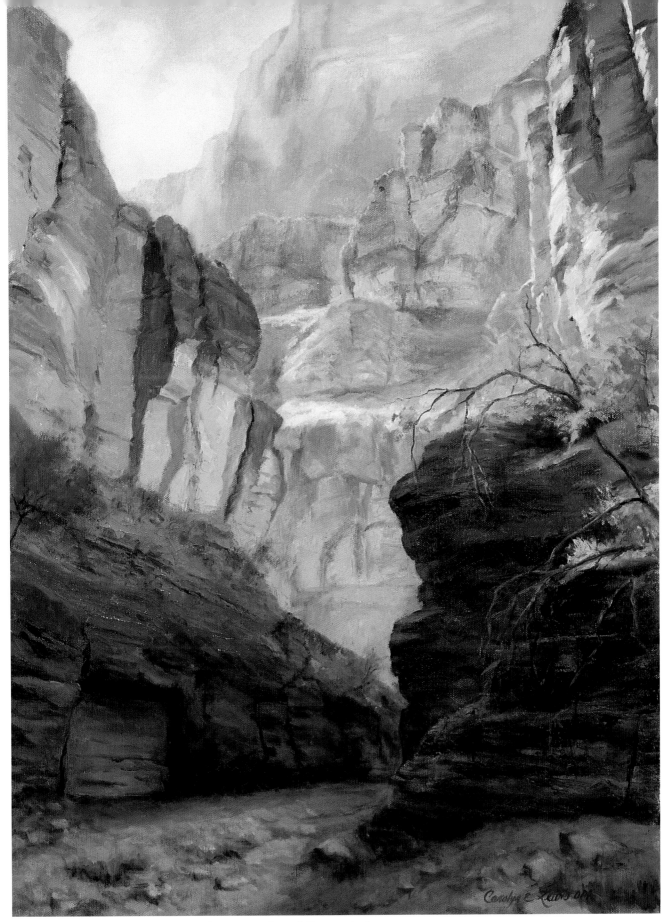

Grand Canyon, Looking Up • *Oil on stretched canvas* • *24" × 18" (61cm × 46cm)*

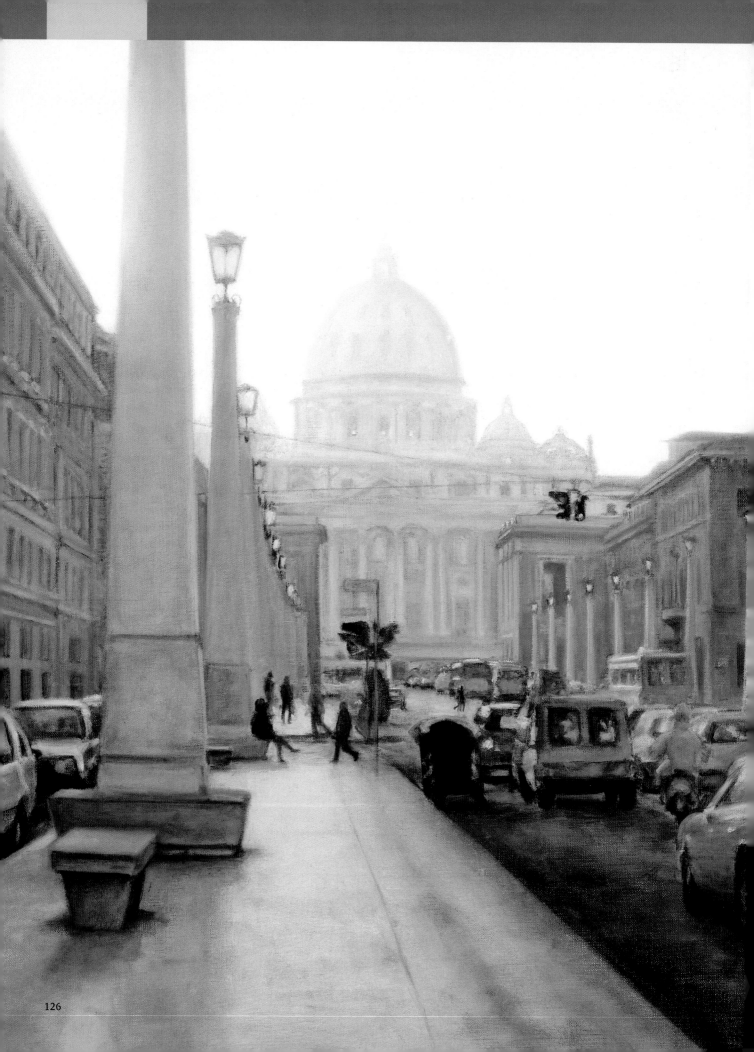

Index

mset Behind St. Peter's • *Oil on canvas* • *28" × 18" (71cm × 46cm)*